9/10

Enjoy!

Lots + Lots
of Love,

Mummy

PHOTOGRAPHY IN
100
WORDS

PHOTOGRAPHY IN
100
WORDS

DAVID CLARK

Exploring the art of photography with fifty of its greatest masters

AMSTERDAM • BOSTON • HEIDELBERG • LONDON
NEW YORK • OXFORD • PARIS • SAN DIEGO
SAN FRANCISCO • SINGAPORE • SYDNEY • TOKYO
Focal Press is an Imprint of Elsevier

Abstract Accident Addictive Ambiguity Anger Atmosphere

Audacity Awakened Awareness Celebrate Challenge Character

Connection Contemplative Commemorate Compelling Completeness

Confrontational Crisis Culture Delight Design Dialog Dilemma

Discipline Discover Distance Dreamlike Drug Dualities Elegant

Elegy Emotional Empathy Engagement Epic Experimenting

Exploration Expression Forensic Geometry Historical Humor Ideas

Identity Improvisation Inquisitive Insight Inspired Instinctive

Interpret Intimacy Intriguing Investigate Irony Logistics Luck

Magic Melancholy Memory Metaphor Mission Moment Motion

Mythic Observation Obsessed Opinion Otherworldly Patience

Pattern Preconception Provoke Poetry Political Question

Recognition Reaction Revealed Romantic Scale Serendipitous

Signal Signature Simplicity Speed Stories Subtractive Suggestion

Surprise Surreptitious Symbolic Trust Truth Uneasy

Unexpected Vision Visualization Witness Wonder

CONTENTS

INTRODUCTION

Photography, in the digital age, is more accessible than at any time in its history. On the internet and in print, photographic images proliferate in huge numbers and are growing hourly. Cameras are easier to use and offer ever higher quality digital files, while the range of images being created is richer and the methods more varied than ever. At the same time, photography-related courses at colleges and universities continue to grow and rising numbers of magazines, books, DVDs and website tutorials offer detailed 'how-to-do-it' advice.

All this photographic activity raises questions. What underlies this hunger for more and more pictures? What inspires photographers to create their images? What drives them and what do they aim to achieve?

I began investigating these questions several years ago, while working as a journalist specializing in photography. When interviewing some of the world's most successful photographers, I was always curious to find out what motivated them. What, I wondered, produced their combination of creative ability and determination to succeed, qualities that set them apart from countless others working in the same field? My questions also related to the wider subject of photography itself. What made them choose this particular medium as a vehicle for creative expression?

When I came to write this book, I decided to focus attention on these sorts of questions and ideas. To keep numbers pleasingly round, I approached the subject through discussions with 50 photographers, using 50 of their pictures and picking out 100 key words that they used to describe their philosophy and approach. The result is an exploration of photography through the work – and the words – of some of its greatest exponents.

The photographers

The photographers featured in this book represent a wide range of genres, including landscape, portrait, documentary, wildlife, still-life and reportage. They are all photographers whose work I admire, so their inclusion is partly a personal choice. However, it's also true to say that most of them are nationally and internationally recognized as leading photographers in their fields. It was a privilege to talk to them during the course of writing this book. They all offered interesting and illuminating insights, both into their own work and photography in general.

The images

The text on each photographer is illustrated by one of their images that is either representative of their work or gives visual expression to an important idea they discuss. Some of these photographs are iconic and internationally famous and others are less

well known, but all are outstanding or remarkable in themselves. I selected the majority of the images myself, sometimes after lengthy deliberation, and the rest were chosen by the photographers.

Of course, a single photograph can only give the slightest suggestion of a photographer's rich and varied body of work. I'd like to encourage readers to further explore their work, and in turn the fascinating world of photography itself. The book therefore concludes with some biographical notes on the photographers and details of their books and websites.

The 100 words

The 100 key words highlighted in the text are ones that emerged during the course of my interviews. I should make it clear that the chosen words have not been highlighted by the photographers and are not intended to encapsulate their work. Broadly, these words have been chosen because they stood out as significant and identified key aspects of a photographer's motivation, approach, aspirations or working methods. Ultimately, they are also words that shed light on the purpose and meaning of photography itself.

For instance, some said they felt compelled to photograph because of their **fascination** for the subject or to **investigate** a situation. During the process of creating images, one said he felt **awakened**; another experienced **wonder**; another **melancholy**. When discussing working methods one photographer wanted to be **experimental**, one worked in a **surreptitious** way and another used a **subtractive** process to arrive at his final images.

Photographers often had very different ideas about what they wanted to achieve. Some sought to offer an **opinion** or **insight** and others to **celebrate** a place or person, or the beauty of nature. Alternatively, some wanted to raise **awareness** or **provoke** a response and were motivated by **anger** about wars, famines or environmental issues. Others invited us to consider abstract ideas, such as **identity**, **ambiguity**, **irony** or the use of **metaphor**.

Although many of the photographers were very different in their approach and results, and the genres they chose to work within, I found the same kinds of words often re-emerged in different contexts. Several photographers talked about **serendipity** or **luck** when capturing a particular moment or when overcoming a technical **challenge** to create an image. Many wanted to express **empathy**, a **connection**, an **engagement** or a sense of having a **dialog** with a subject. They had a sense of curiosity about the world, they wanted to **explore**, **discover** or ask a **question**.

The only rule I gave myself when compiling the key words was that a word could only be highlighted once, even if also used by another photographer. As you progress through the book, you'll find that these words gradually accumulate. Together they form an admittedly partial, perhaps idiosyncratic, but certainly unique photographic vocabulary and distill something of the essence of photography – in 100 words.

DAVID BAILEY

When English photographer David Bailey shoots a portrait, he aims to make it as uncomplicated and direct as possible. 'I often use a white background because it doesn't interfere with anything,' Bailey says. 'I aim for a timeless look, one that doesn't date. I always think that if something looks old-fashioned, it wasn't any good in the first place.

'For me, **simplicity** is the ultimate aim, combined with the perfect **accident**. All creativity is an accident. That's why I prefer film cameras. Digital takes away the accident. If you do that, you take away the creativity. All those pictures on digital cameras are all perfect. And they're perfectly boring.'

He tries not to have preconceived ideas about a person before they arrive for a shoot. 'I don't ever really think about who a person is, how I'm going to make them look or whether I'm going to like them,' he says. 'I just take them as they are.' The key element in Bailey's portraiture is the relationship he develops with his subjects. The expression and pose in his images arise spontaneously from that relationship.

'I spend much more time talking than photographing,' he continues. 'For me, talking is part of taking the picture. I'm always amazed when photographers come to my studio and photograph me and hardly say anything. All they say is, "Smile," and I say "No, if you want me to smile it's up to you to make me smile. I'm not a bloody actor."'

Bailey photographed rock musician Noel Gallagher by going in close to his face with a 5x4 camera. The resulting limited depth of field accentuates the parts of his face in focus and adds impact. 'I like Noel and I tried to get a picture that showed his intelligence,' Bailey says. Yet he also achieves a penetrating portrait that reveals a more vulnerable side to Gallagher's normally self-assured persona.

Simplicity…accident…ideas…

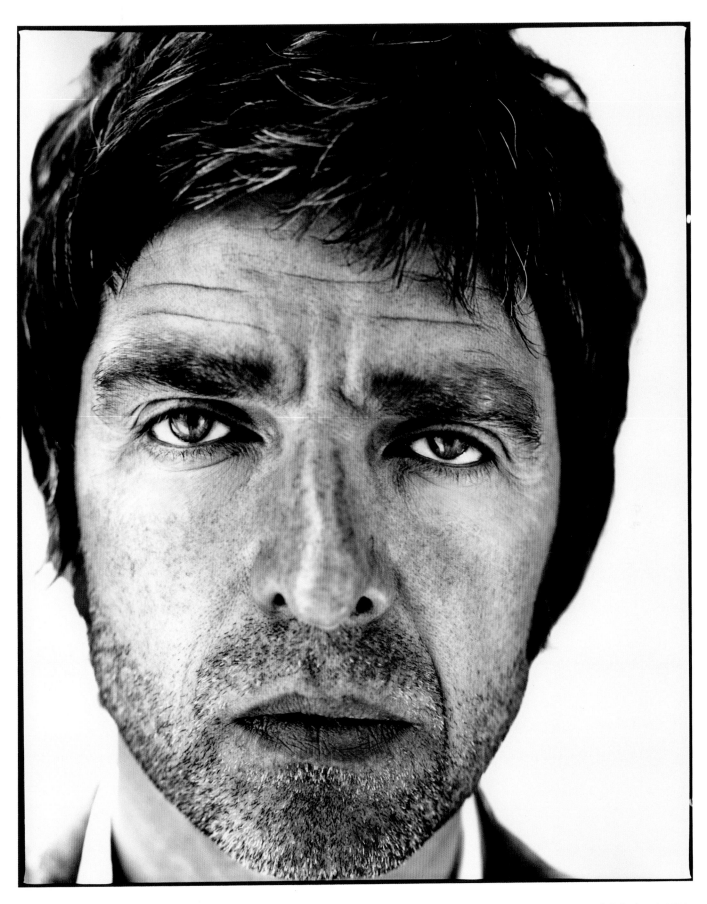

Noel Gallagher | 2008 **9**

JONAS BENDIKSEN

'We live in an age in which we have an unprecedented number of images around us,' says Norwegian photojournalist Jonas Bendiksen. 'One cannot walk on the street for more than five minutes without seeing more photographs than we can count. On the web, from news outlets to photo-sharing sites such as Flickr, the amount of imagery available is increasing by the tens of millions a day. How do we stay relevant as photographers in such a situation? For me, the answer is that although we see millions of fairly good images being produced every day, we don't see millions of good **ideas**, or great stories. And this is what drives me.'

Bendiksen's projects explore ideas or raise questions about particular societies and often focus on long-term issues that are outside the main news headlines. His seven-year project, *Satellites*, concentrated on isolated communities on the periphery of the former Soviet Union. Bendiksen immersed himself in these communities. 'While I was living there, I realized that there were all these places whose history doesn't conform to the textbook version of the collapse of the former Soviet Union,' he says. 'These were the **stories** I wanted to explore.'

Many of the images in the project show 'space junk' – pieces of Russian spacecraft – that have crashed back to Earth in rural locations. This space debris is made from high-grade metals which local people cut up and sell. This intriguing and surreal image shows two villagers dismantling the remains of a second booster stage of a Soyuz spacecraft.

'I was driving towards this scene in the Altai territory, on a late summer day,' Bendiksen remembers. 'Suddenly, it was as if snow flurries were hitting the car windscreen. It took us a few moments to realize we were surrounded by thousands, or millions, of white butterflies. This was purely by chance, and mixed with the passing storm clouds in the background, it was an electric moment.'

…accident…ideas…stories…motion…

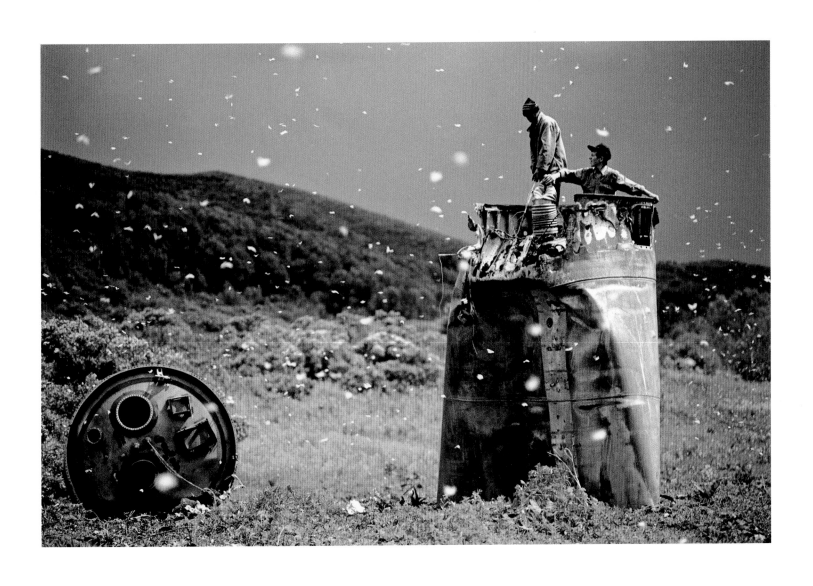

HARRY BENSON

Harry Benson is a Scottish-born press photographer with an established reputation for being a lone wolf, operating away from the pack. His single-minded determination to get to the center of events has resulted in a rich store of images from a long and varied career.

Benson's photographs have a vitality that he believes is sometimes missing from press pictures today. 'To me, photography is about **motion**,' he says. 'To get a dynamic picture, you've got to have movement. These days, a lot of photographers freeze everything up with a nice background. Good news pictures have life and energy to them, a crisis. That's what you're looking for – a **crisis**.' For Benson, the 'crisis' is the defining moment of a news event. If you capture that action, gesture or expression, you say all that needs to be said about the subject.

His photograph of a panic-stricken Ethel Kennedy was taken immediately after her husband, Senator Robert Kennedy, was shot in Los Angeles in June 1968, while campaigning to be the US President. Benson's picture represents a crisis both literally and metaphorically. 'After he was shot, there was mayhem,' recalls Benson. 'Ethel's husband was bleeding to death. People were screaming and crying and she was trying to push them away. She turned to us and said, "Give him air, give him air," and that's when I took the picture.'

Although Benson had photographed Robert Kennedy many times on the campaign trail and liked him, he couldn't let his emotions stop him photographing what was happening. 'I was thinking, let me mess up tomorrow, but not today,' he says. 'I hate to say it, but I knew I just had to get it done. It was an assassination and I had to record it. When they took him to hospital, some photographers followed but I didn't go. I got very close to him and saw the blood pouring out of his head. I knew he was gone.'

…stories…motion…crisis…wonder…

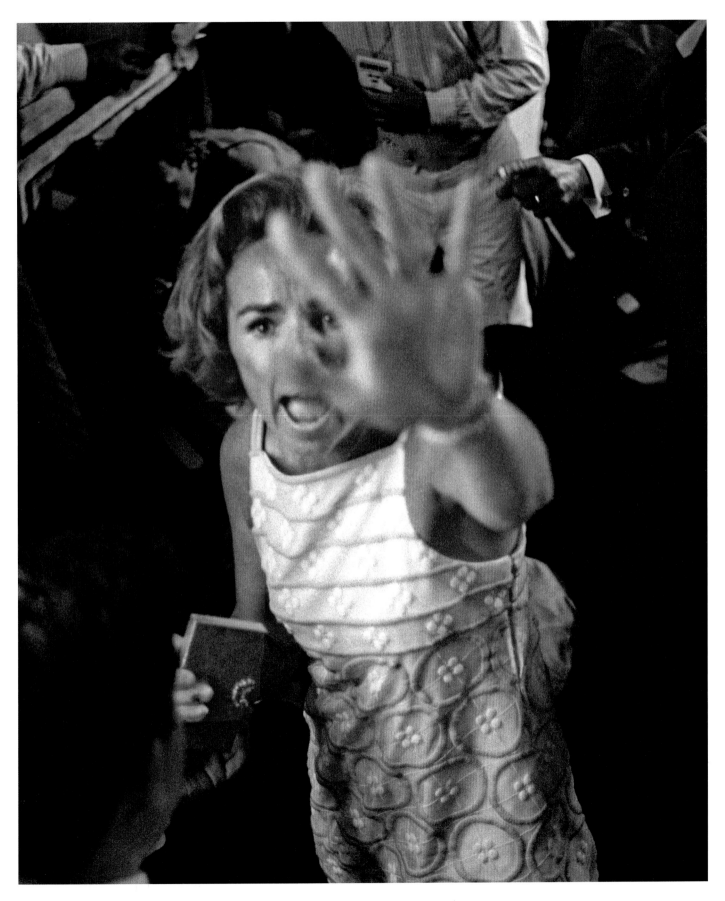

Ethel Kennedy | Ambassador Hotel, Los Angeles, 1968 **13**

YANN-ARTHUS BERTRAND

French photographer Yann-Arthus Bertrand's *The Earth from Above* is a unique aerial photographic survey. It consists of over 500,000 photographs made in 150 countries. The resulting books have sold over 3 million copies and associated exhibitions have attracted over 100 million visitors. It is one of the largest projects in photographic history and remains ongoing.

Bertrand shoots from light aircraft or helicopters, at altitudes ranging from 2000 metres to 20 metres. It is difficult and sometimes dangerous work and requires careful planning and expert technique. His motivation initially sprang from the 1992 Earth Summit in Rio, which declared the need for action on climate change. 'I heard for the first time words like sustainability, global warming, environment and fair trade,' he says. 'I clearly understood then what was at stake and it has guided me since.'

Bertrand's awareness that 'man cannot be dissociated from the landscape' encouraged him to employ a dizzying aerial perspective. At first sight these awe-inspiring images seem to simply celebrate the Earth's diversity. Their beauty draws us in. 'In front of a vast landscape, we all share the same feeling of **wonder**,' he says. 'When nature is beautiful, we are all moved by it.' But Bertrand uses the façade of beauty to make serious points about what lies behind it. He says he aims 'to elicit emotion to **provoke** thought and the need to know more, to read the caption and learn what is at stake in the image.'

His photograph of the Athabasca Oil Sands arrests attention from the contrast of the smooth, swirling liquidity of oil's surface against the hard lines scored into the land. It's only when you realize that the tiny vehicle in the frame is actually a giant 400-tonne truck that the scale becomes apparent. 'I wanted to show that men were ready to face many difficulties and a lot of pollution in order to get their hands on more oil,' Bertrand says. 'It's like an addiction.'

To ensure his environmental message gets across, Bertrand insists that pictures and their captions – explaining the true purpose of the images – are inseparable.

...crisis...**wonder**...**provoke**...metaphor...

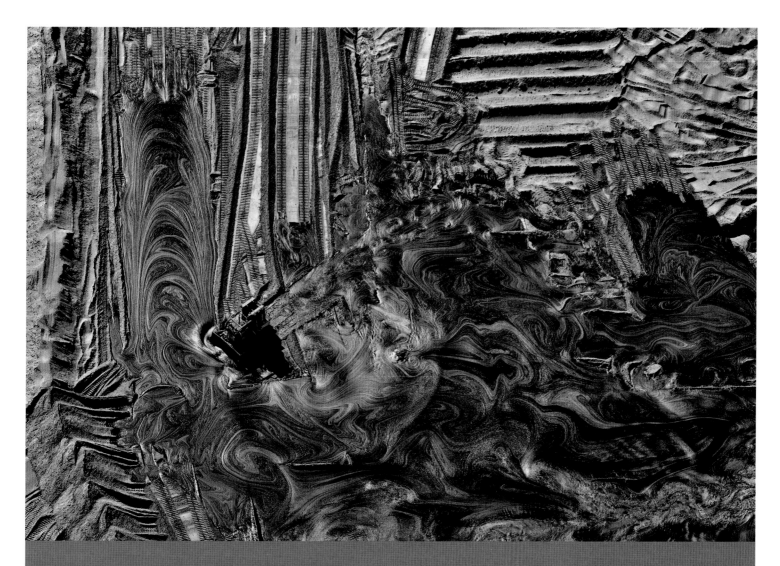

Exploited for the last 30 years, Alberta's oil sands represent the second largest proven oil reserves in the world, second only to Saudi Arabia, with 173 billion barrels. To obtain a barrel (159 litres) of crude oil, one must extract two tons of overlying peat and dirt and two tons of sand. The land must be scraped to a depth of 60 meters by giant excavators and then 400-tonne trucks transport the tar sands to the extraction plants. Water pumped from rivers is used to separate the sand and the bitumen in a hot-water wash. The bitumen is then sent to another plant to be converted into synthetic crude oil. Most of it flows by pipeline south of the border to the United States. If this activity has brought prosperity to this part of the country, the provincial government, the oil companies and their numerous employees, it is to the detriment of the natural environment. The destruction of the boreal forest along the Athabasca River, the stripped land, the toxic residues and the contaminated water make the environmental damage very heavy. Even if oil sands mining is not always as profitable when oil prices collapse, its long-term prospects are still good, unless measures to combat climate change put an end to these destructive operations.

JOHN BLAKEMORE

English photographer John Blakemore has made images throughout his life. As a child he drew and painted and he started using a camera in his early 20s. 'Until then I had never considered photography,' he told me. 'But once I began photographing, that whole process became a way of making sense of one's life. In most aspects my life is fairly chaotic and for me image-making is about finding one's place in that chaos.'

Photography, for Blakemore, became a necessary means of self-expression. After initially pursuing documentary work, he went on to become a leading landscape photographer. He abandoned this work in the early 1980s, but it was inevitable that his need to photograph would find another outlet. 'I began being interested in the photograph as a **metaphor** to express something about my feelings,' he says. 'I started working on different photographic sequences that made a connection with my emotional state at the time.'

By chance, he began photographing tulips, which for him became 'an object of attention and fascination.' He felt that this flower had unique qualities. 'If I'd been photographing daffodils, I probably wouldn't have carried on photographing flowers for so long,' he says. 'The tulip is a very elegant, gestural flower.' He went on to spend nine years making images of tulips and this lengthy scrutiny culminated in Blakemore's book *The Stilled Gaze*.

This beautifully composed tulip photograph is a rich, sombre and sensual flower study. The tulips were lilac-colored, arranged on a black piece of paper and lit with daylight. The subtle power of the image springs from an expert control of the print's tonal values.

However, Blakemore regards his tulip pictures as having a wider significance. 'I don't see these pictures as being about tulips at all,' he says. 'I see them as an **exploration** in picture-making, although the tulip was text and pretext for that activity. For me, it was about looking at ways of using light and discovering the possibilities of photography.'

…**provoke**…**metaphor**…**exploration**…**emotional**…

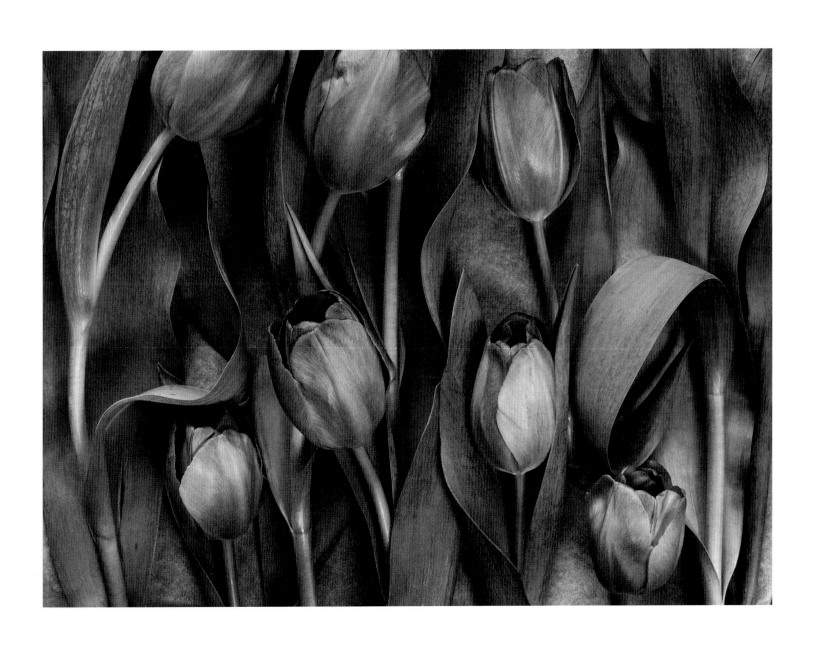

STEVE BLOOM

In 1990, Steve Bloom's return trip to his South African homeland spurred a new direction in his life. 'I started photographing wildlife because it was so far removed from the city life I was leading,' he says. 'I suddenly realized that there is a fascinating, somewhat different world beyond where the pavements stop.'

He believes that a great wildlife photograph is 'one which gives the viewer a strong sense of the sentient nature of the animal, while simultaneously touching the viewer emotionally.' Achieving that aim is a challenge in itself, but the plethora of wildlife images shot each year creates a further demand: the necessity of finding new ways to arrest the viewer's attention.

Bloom, in common with other wildlife photographers, aims to heighten awareness of endangered species and make people more environmentally conscious. This means aiming to escape the cliché and creating images that make people see familiar subjects in a new way. 'The photographic image has a great capacity for invoking an **emotional** response in people,' Bloom says. 'The **challenge** of producing such images is what drives me to photography.'

While shooting the pictures for his book *Elephant!* he aimed to capture a rare and unusual sight: elephants swimming in the sea, photographed from underwater. 'I decided on the underwater elephant images as I knew they would be a great statement about the versatility of elephants,' he remembers. 'However, because elephants are very large and water is dense, I had to use a fisheye lens and swim perilously close to them.'

Bloom braved both dangers and technical difficulties and captured the spectacle of an elephant, liberated from the normal restrictions of its size and weight by the sea's buoyancy, gracefully propelling itself through the water. This remarkable photograph, made when Bloom swam directly underneath the elephant, has a simple, almost abstract quality. It captures a familiar animal in an original and poignant way.

...**exploration**...**emotional**...**challenge**...**truth**...

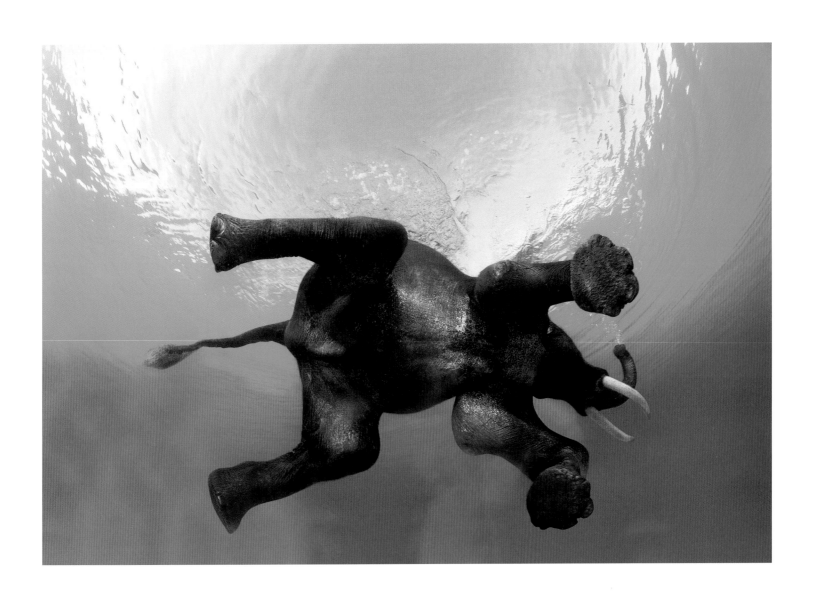

HARRY BORDEN

'When I photograph someone, I'm interested in taking a picture that has a **truth** to it,' says English portrait photographer Harry Borden. 'I want it to be representative of them, to show them in a way that people who know them intimately would immediately recognize.' Getting to the real person beneath the public persona can be particularly challenging with celebrities and public figures. Borden's job is to peel away the layers and reveal something of his subjects' true personality.

'I ask them to have absence of thought, so that they get out of the visual schtick they would normally do automatically,' he says. He avoids distracting or distorting photographic techniques and takes time to get to know the person he's photographing. 'I find that if you have a dignified and meaningful exchange with your subject and just see what happens, you get a better picture than if you have an agenda that makes them conform to the public's notion of what they are like.'

For his portrait of the flamboyant entrepreneur Richard Branson, Borden asked him to stand in an atrium at Heathrow airport, against a painted metal backdrop he found in the Virgin Upper Class Lounge. 'The atrium was like a daylight studio and had soft natural daylight,' Borden remembers. 'I didn't need flash or reflectors and kept it very simple.' The angel's wings, a clear reference to Branson's love of flying and prominence in the aviation industry, are a visually arresting device. The key to the picture, however, is Branson's quietly thoughtful and benevolent expression.

The picture was a success and won him a coveted World Press Award, but Borden admits that its appearance owes as much to chance as to careful arrangement. 'About a year afterwards, I realized that Richard had put the wings on upside down, so he's actually more a sprite than an angel,' he says. 'But if he hadn't put them on that way, we wouldn't have seen them so clearly from the angle I shot the picture. It was one of those interesting, **serendipitous** things that sometimes happen.'

...challenge...truth...serendipitous...inquisitive...

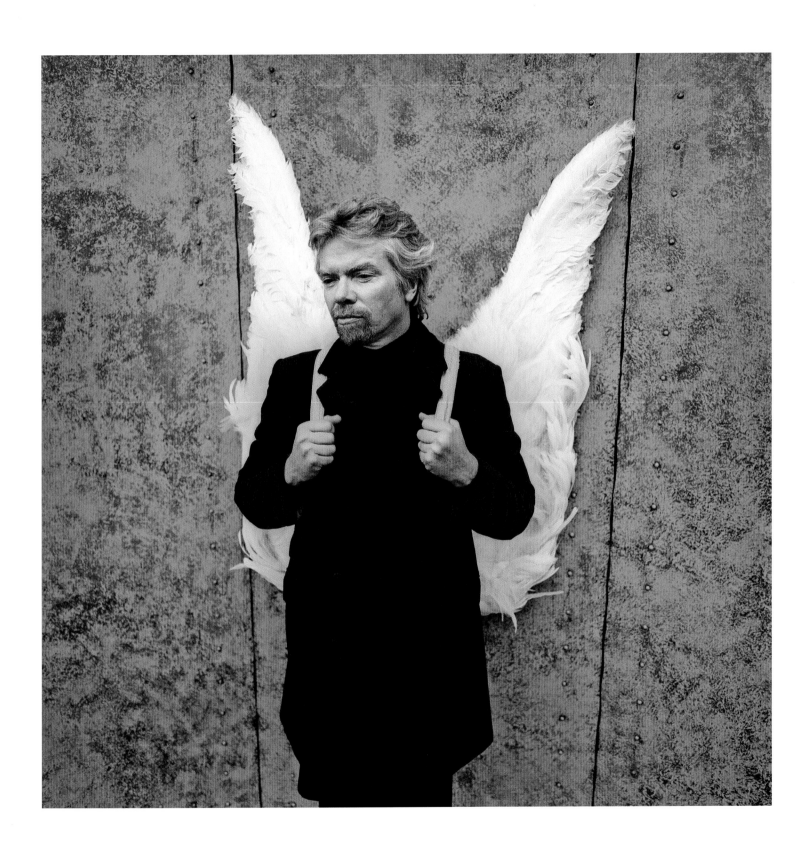

POLLY BORLAND

'People have always fascinated me,' says Polly Borland. 'I've always been a people photographer. I don't know why, because human beings are very scary. I think it's an aesthetic thing. I like looking at people and the way they behave and dress and I like talking to them. I'm **inquisitive**. And usually I'm more inquisitive about people than anything else.

'I think portrait photographers need a range of social skills. You've got to empathize with your subject, be friendly and make them feel relaxed and comfortable. The photography itself is quite separate: you've got to know what you're doing, but it has to be almost invisible so you can focus your attention on the person.'

When Borland became one of a select group of photographers invited to make portraits of The Queen to mark her Golden Jubilee year, she produced one of the most bold and eye-catching royal portraits ever made. Bright, colorful and with more than a hint of Warhol-style iconography, it's strikingly different to conventional royal portraits. Borland says that she aims to capture her initial impression of a sitter, which in this case took her by surprise. 'What struck me about The Queen was how beautiful and glamorous and rich she really looked,' she says. 'You don't usually see that in photographs.'

The style of the image was partly dictated by circumstances. Borland wasn't inspired by the particular Buckingham Palace room she had been offered, so set up her own glittering gold background. She says she had just five minutes to do the portrait. 'I used ringflash, not because I thought it would be flattering to her, but because I needed a direct light to bring out the sparkles in the background,' she says. 'The person who was timing me said that nobody had ever photographed her that close. What made me do it? I just think it was a bit of Australian **audacity**.'

...serendipitous...**inquisitive...audacity**...mythic...

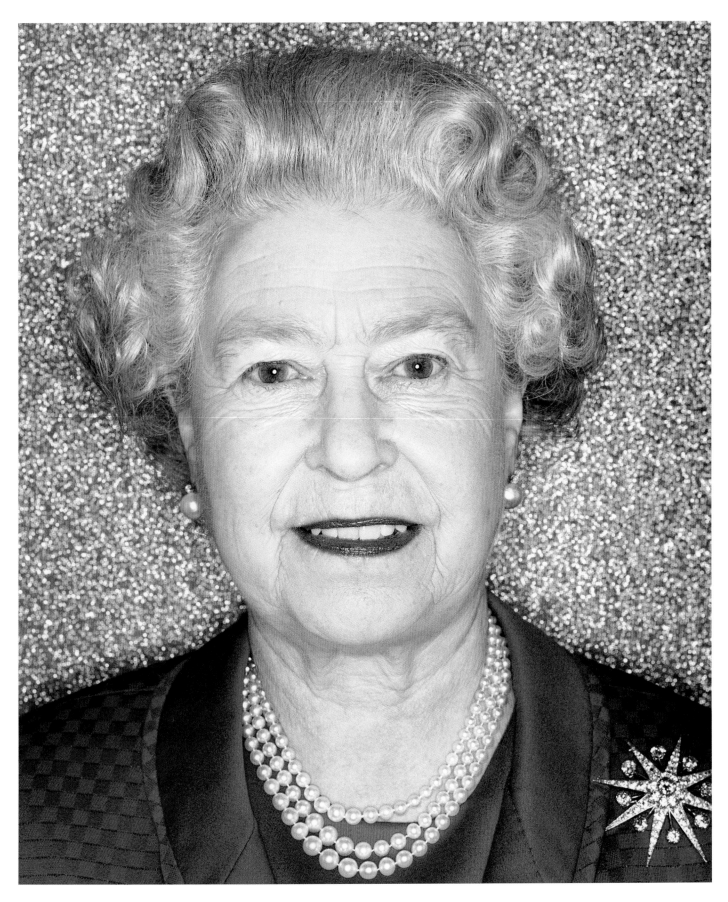

NICK BRANDT

English photographer Nick Brandt has a unique approach to wildlife. Instead of being conventional, shooting digitally with long lenses and printing in color, he uses a medium format camera, relatively short lenses and black and white film. Brandt's images have more in common with fine art portraits of people than wildlife documentary shots. They offer an unashamedly romantic viewpoint that emphasizes the untamed beauty of the animals and their surroundings.

'My photography is driven by my love of animals and the natural world,' he says. 'I photograph animals in the same way I would a human being, and I get close because I like to frame them against sky and within their environment.' He finds the wildlife in East Africa especially inspirational. 'Animals such as elephants and lions have a **mythic**, iconic quality,' he continues. I became a photographer because I wanted to capture my feelings for them and the world they inhabit. I want my work to be an **elegy** to a vanishing world and to make people aware of what is disappearing.'

Brandt's images often show the animals at times of stillness, and even this image of an elephant in action has a strangely static, statuesque quality. He says he usually photographs elephants on cloudy days. 'For me, their shapes are more boldly iconic when unencumbered by shadows and highlights,' he says. However, this powerful picture was shot in bright sunlight. It freezes the moment that the elephant has thrown dust over itself to protect its back from the harsh midday sun. The light, from directly overhead, gives its tough, wrinkled skin a granite-like quality.

While Brandt's photograph is a celebration of this awe-inspiring animal, it also contains a reminder of the elephant's endangered status. 'This elephant bull is one of the few left with tusks of any decent size, and even these are small in comparison to the tusks of elephants from 20 years ago,' he says. 'All the rest have been killed by poachers.'

...audacity...**mythic**...**elegy**...discover...

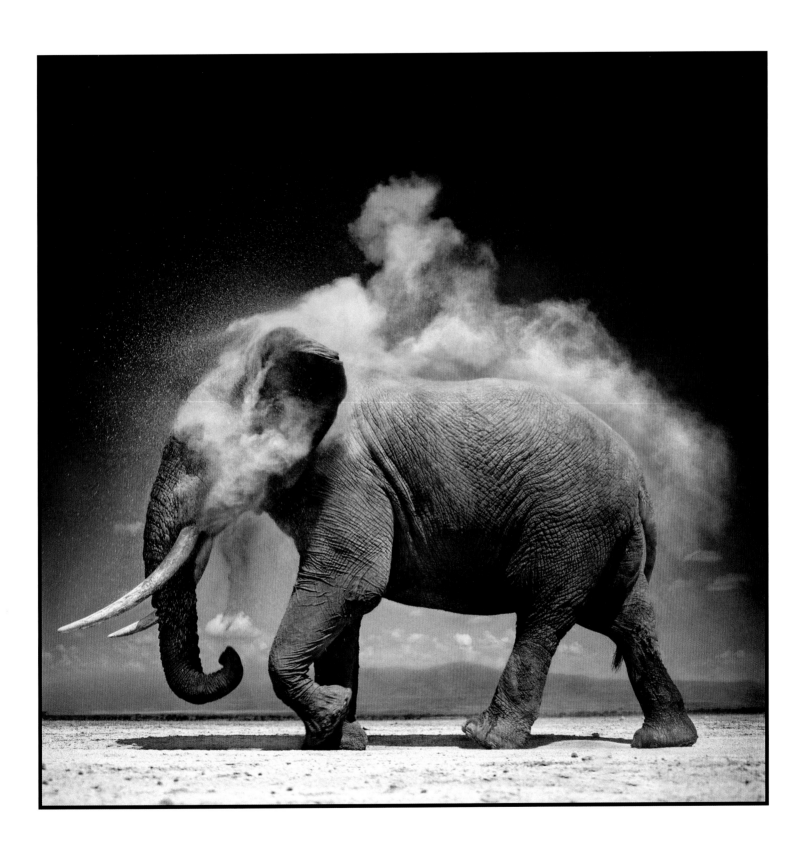

RENÉ BURRI

René Burri grew up with an insatiable curiosity about the world. He was born and brought up in Switzerland and felt restricted by his country's geography. 'I was always climbing to the tops of mountains and seeing more mountains,' he later recalled. During his art school studies he became conscious of his natural affinity with the camera and realized that a photojournalistic career offered both a means of escape and the opportunity to explore. 'My first Leica became my third eye and through that I could **discover** the world,' Burri says. 'I wanted to investigate every nook and cranny.'

Sometimes his nationality has been a positive advantage. In January 1963, just a few months after the Cuban Missile Crisis, *Look* magazine had arranged an exclusive interview in Havana with the revolutionary leader Che Guevara, then the Minister for Industry and one of the most controversial figures in world politics. A photographer was needed and Burri's reputation, together with his Swiss passport and its suggestion of political neutrality, made him first choice for the assignment.

He found Guevara in a confrontational mood. The blinds were drawn and he refused Burri's request to let in more light. 'Che was like a caged tiger in the office,' Burri recalls. 'He argued with the journalist like cat and dog for over two hours. He ignored me almost completely and I was able to shoot eight rolls of film.' Guevara's vitality and charisma are captured in this image. Its iconic status is ensured by the inclusion of the quintessential Cuban accessory – a cigar.

Burri believes it is vital for photographers to offer their own personal vision of a subject. 'Photography is not simple documentation,' he says. 'Even though it's mechanical, you should use the camera for the **expression** of some kind of feeling – empathy, sympathy, love, hate or whatever it is. And if you don't capture it in the moment, it doesn't get stronger afterwards. While photographing, you have to employ your mind, your soul and your heart.'

...elegy...**discover**...**expression**...dilemma...

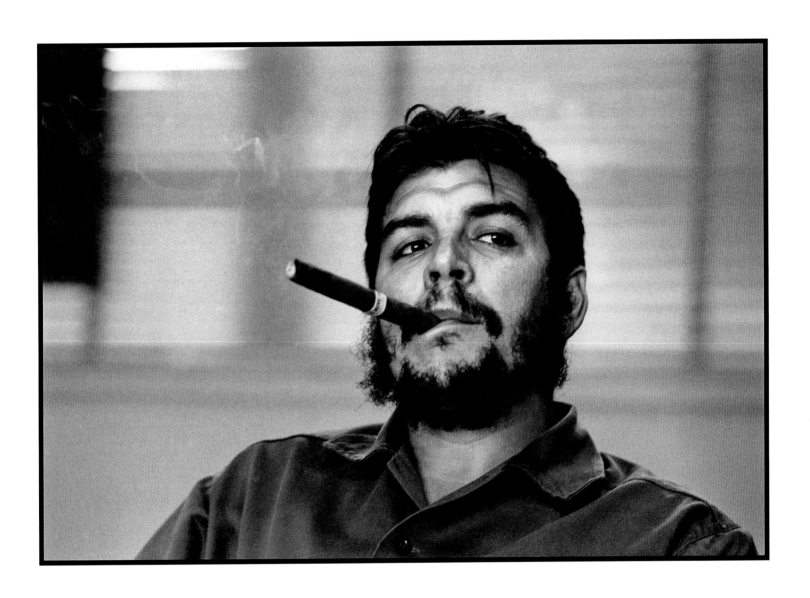

Che Guevara in his Office | Havana, Cuba, 1963 **27**

EDWARD BURTYNSKY

The work of Canadian documentary photographer Edward Burtynsky is created with a clear purpose: to make us think about the material world around us. He documents the life of the products we consume, from gathering raw materials in mines and quarries to the huge dumps and recycling plants where products end up. One of his central themes is the dilemma between our desire for a particular way of life and the impact this lifestyle has on the planet.

'**Dilemma** is a key word,' he says, 'as it does point to a condition we've found ourselves in, where we've embraced the myth of endless growth and the notion that accumulation of material wealth is the surest way to happiness. The core of the dilemma is that while we make a vast number of products, the thing we produce most of is waste.'

Burtynsky makes his point through the sheer size of the things he photographs. 'The one operating principle in all my work is **scale**,' he says. 'Human beings taking things from nature to provide for themselves is not new, but the scale of it is new. So if I wanted to photograph a quarry, I'd look for the mother of all quarries, to show the gigantic proportions of what we take from the land.'

His recent work on China's rapid industrial development is stunning in its use of scale, whether documenting the colossal Three Gorges Dam project or giant factories. This image, made in a chicken processing plant, shows row after row of workers in their pink protective uniforms. Vast numbers of people are employed in China's factories, Burtynsky explains, as they provide a cheaper alternative to the robotics used in the West – though at the cost of an alien and dehumanized working environment.

'I try to find subjects that are visually compelling and possibly tweak people's sense of wonder,' he says. 'I want to make people stop and ask questions about that subject or place – to think about what they are looking at, where it is, how it got there and why it is being shown.'

…**expression**…**dilemma**…**scale**…**opinion**…

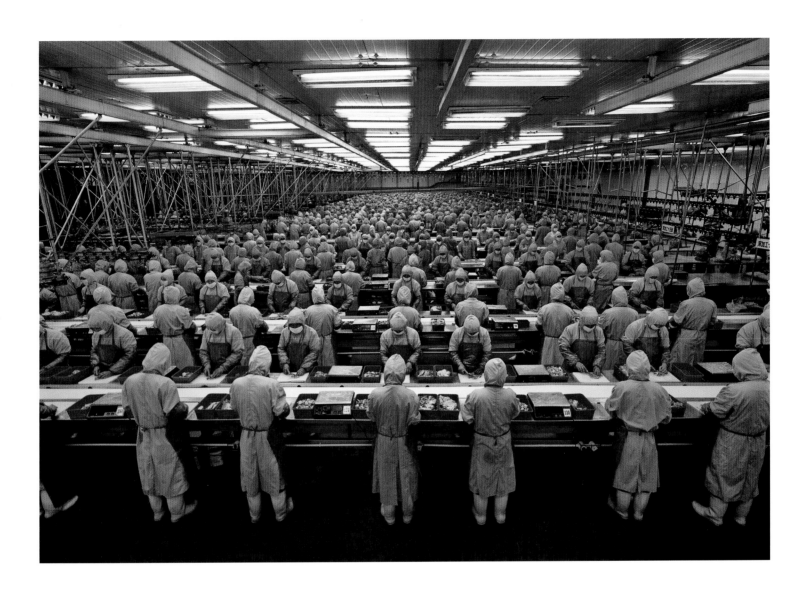

DAN CHUNG

'I've always been interested in photography that records and reflects current issues,' says British press photographer Dan Chung. 'If you're fascinated by how the world works – as I am – it's much better to have your own personal insight from being there, on the spot, as things are happening.' His work as a press photographer on *The Guardian* has led him to cover major international stories including wars and natural disasters. These assignments are often difficult, dangerous and emotionally stressful, but he believes it's a privilege to do them.

'I can't imagine that any human could see some of the things I do and not come away slightly traumatized by the experience,' he says. 'But we all know that this stuff exists. It doesn't go away because you don't see it. I would like to at least see enough to form my own **opinion**, both personally and photographically.'

However, front-line work demands that photographic skills take second place to practicalities. 'Taking the picture is almost the easy part,' Chung continues. 'The hard part is getting yourself in a position to take it. That's not just about being physically in the right place, it's about having the right contacts. **Logistics** are absolutely key. You have to be resourceful and you have to know how to interact with people.'

Chung's photograph, taken during the siege of Basra in the second Iraq War in 2004, uses one family as a symbol of what was happening to thousands of others. The little girl's tearful expression encapsulates the distress, fear and confusion that war brings to civilian life. 'The Iraqi army and insurgents still held the city at this point and many families were fleeing the city over a bridge that the British controlled,' he says. 'I focused in on one family as they crossed over to the British side. The young girl made the shot because she was wearing a beautiful dress despite being in that crazy situation.'

…scale…opinion…logistics…atmosphere…

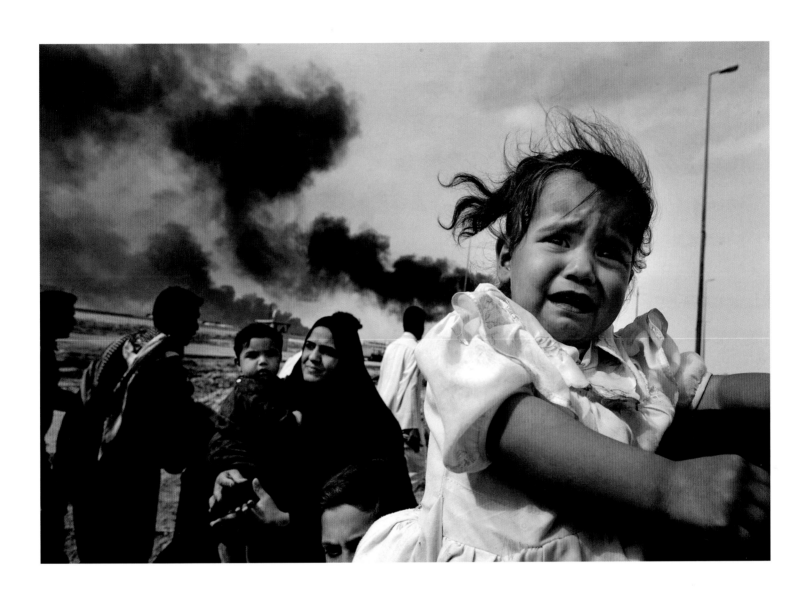

JOE CORNISH

English landscape photographer Joe Cornish's love of the countryside and coast, particularly around the north of England and Scotland, inspires him to record it in a way that is 'as natural as possible, yet dramatic enough to be interesting.' While his work has a recognizable style, he believes it's important for the subject to speak directly through the image without using distracting photographic techniques.

His images have a deceptive simplicity that disguises the artistry and dedication that goes into making them. 'Very few images are easy to make,' Cornish says, 'but they must be so well-balanced and executed that they seem effortless. The irony is that the opposite was usually the case.' Above all, he strives to capture and celebrate the beauty of the natural world. 'I aim to achieve, if I can, a sense of wonder, an **atmosphere**, a feeling for the light, a **connection** to the place and to the moment,' he says. 'My goal is to make my photographs an authentic reflection of what I think, what I feel, and what I believe.'

Great images are made when the photographer most suited to the subject is in the right place at the right time. One bitterly cold and windy November afternoon, he was standing on the West Pier at Whitby on the North Yorkshire coast. A heavy shower of rain and sleet passed over, leaving the strong lines in the pier's decking soaking and dark, but mirror-like. A clearing sky allowed the setting sun to illuminate the cloud from that same squall as it retreated east over the North Sea. These pink hues reflected vividly in the boardwalk.

This photograph was made at the moment when the cloud was correctly framed within the composition. 'It was one of those rare gifts of light,' he says. 'Although I have stood in that place a hundred times since, this remains my strongest image of and from the pier.'

…logistics…**atmosphere…connection**…investigate…

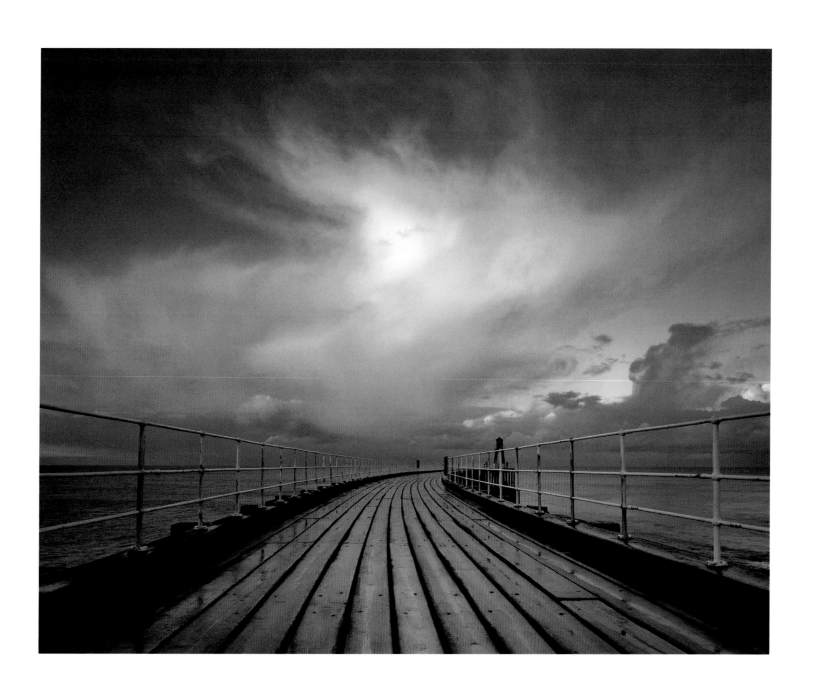

DAVID CREEDON

Ghosts of the Faithful Departed, a portfolio of images by Irishman David Creedon, uses the documentary genre to give a window on the past. 'I wanted to **investigate** not only an individual family's history but the story of a generation,' he says. The project consists of images made in a number of derelict houses in rural Ireland; they were abandoned as a consequence of the large-scale emigration during the economic depression of the 1950s and 60s.

He discovered many of these houses around Ireland and often found the same things in them: clothes, religious images and letters from family members who had left to find a new life abroad. After the death of those left behind, the houses would simply be left to decay. He only entered houses that were already open to the elements and photographed them as he found them, using natural light. The rooms' darkness required long exposures of up to five minutes. The house in this image was one he glimpsed through trees while driving through West Cork. It had been deserted for thirty years.

'This was the most interesting of all the houses I photographed,' Creedon says. 'It was like a time capsule containing things I remembered from my own childhood. In the kitchen, the bright green paint was peeling from the walls and natural light from the windows was emphasizing its texture. The stove had rusted and was collapsing.' The image is a study in the effects of time, but it also symbolizes the many forgotten homes and divided families all over Ireland.

Creedon says his project had an unexpected emotional effect on him. 'I felt very uneasy when I was taking these photographs,' he says. 'I felt I was disturbing something, and sometimes the hair literally stood up on the back of my neck.

'Everyone knew about the emigration from Ireland, but not many people paid much attention to the people who stayed behind. I wanted to **commemorate** those people; the isolation, loneliness and continuing hardships that they suffered.'

...connection...**investigate**...**commemorate**...awareness...

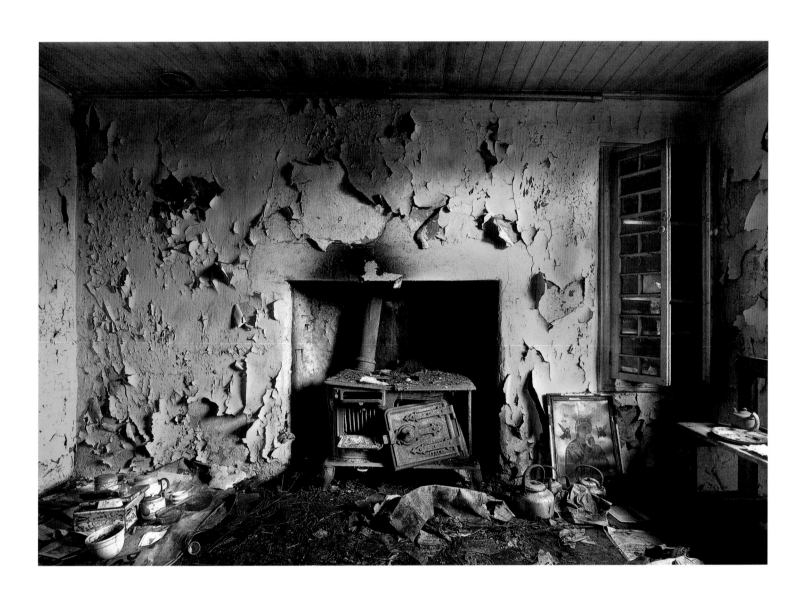

NICK DANZIGER

English photographer Nick Danziger has produced documentary projects on high-profile politicians and religious leaders, but the work closest to his heart concerns people whose voices are seldom heard. He has covered famine in Ethiopia and AIDS-related stories in India and Russia. 'For me this work is a journey of exploration,' he says. 'If it can raise **awareness**, it's a great bonus. In the main, I aim to go to rarely visited corners, whether geographically or within society, to cover stories least expressed and viewed in photography.'

While he feels it is 'blasé and pretentious' to think that photography can directly change things in the world, he believes it can have a positive influence. 'In my experience, really moving stories can inspire people to want to do something, whether to make a donation to an individual or an organization, or motivate people to work in an area they might not have considered working in before,' he says. 'For me, one of the most rewarding outcome is if someone tells me that an image or a story has **inspired** them.'

One of his most highly regarded projects was *The British*, a book that resulted from documenting British people and institutions over an eight-year period. This journey took him from behind the scenes at the House of Lords and the judiciary to the poorest inner-city areas. He found 'a country of unfulfilled promise, caught between beauty and decay'. Yet sometimes this work produced joyful images in places he least expected it.

Danziger was walking through one of Glasgow's most deprived areas on a hot summer's day and found that local teenagers had broken a fire hydrant and were cooling off in the jet of water. 'To see these kids playing was such a contrast from the really dour surroundings that they live in,' he says. 'It's hard to capture those moments of exuberance because there are fewer of them. But I think it's important to reflect different sides of people's lives, not just the difficult side.'

...commemorate...**awareness**...**inspired**...otherwordly...

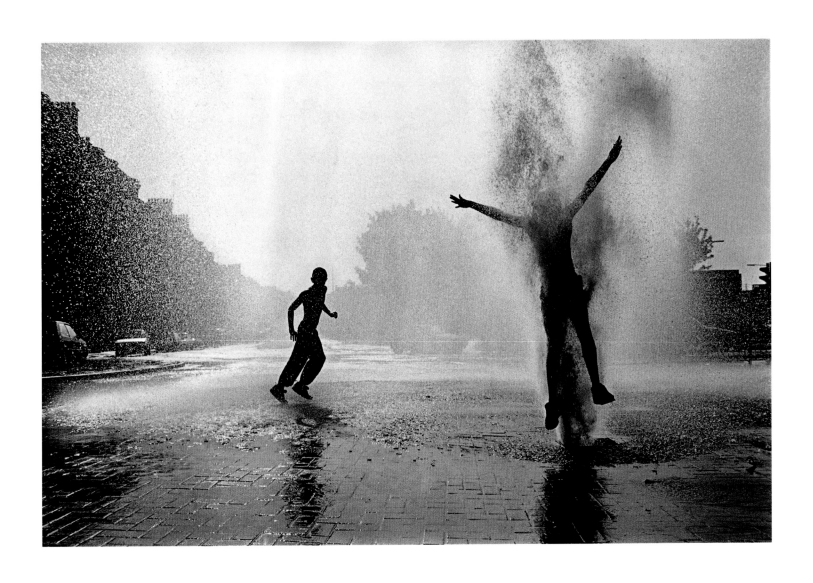

DAVID DOUBILET

David Doubilet's spectacular images create order from the chaos of underwater life and reflect his lifelong passion for the world's oceans and the countless life-forms they support. 'I love the sea because it has that **otherworldly** aspect,' says the American underwater photography specialist. 'It covers most of our planet but visually it is a far different world. It's an extraordinarily beautiful, mysterious, delicate environment, where rules – even the rules of how you photograph things – are all changed. It keeps you looking and looking and it becomes **addictive**.'

He aims to communicate the grandeur of the underwater world through innovative technique, but also to document the changes occurring in the world's oceans as a result of global warming, pollution and overfishing. These aims converge in photographs that reveal underwater life at its most colorful and fascinating.

'I think that if you show the jewel and say, this is what we protect, this is what we fight for, it makes all wildlife photographers into very important journalists,' Doubilet says. 'They show what exists, they talk about the problems that surround them and they will affect the solution. Our ethic to save whales, for example, has come from people taking pictures of whales.'

This stunning photograph, showing a sea lion surrounded by a swirling school of salema, fuses technical virtuosity with perfect timing. Doubilet lit the fish with two underwater flashes and captured the sea lion in mid-hunt. Despite its aesthetic appeal, Doubilet says the scene represents an ocean in peril.

'I photographed the sea lion after the "Super El Niño" in 1998–9,' he remembers. 'The much warmer waters had driven away the sea lion's normal prey and they were hunting fish to stay alive. So it was a kind of ballet of starvation, but ultimately beautiful, because you see how the seals dive in and how the fish literally create a circle of confusion around them. It's a piece of geometry in a place that normally has no geometry at all. And that's why the picture has some power.'

…inspired…**otherworldly**…**addictive**…humor…

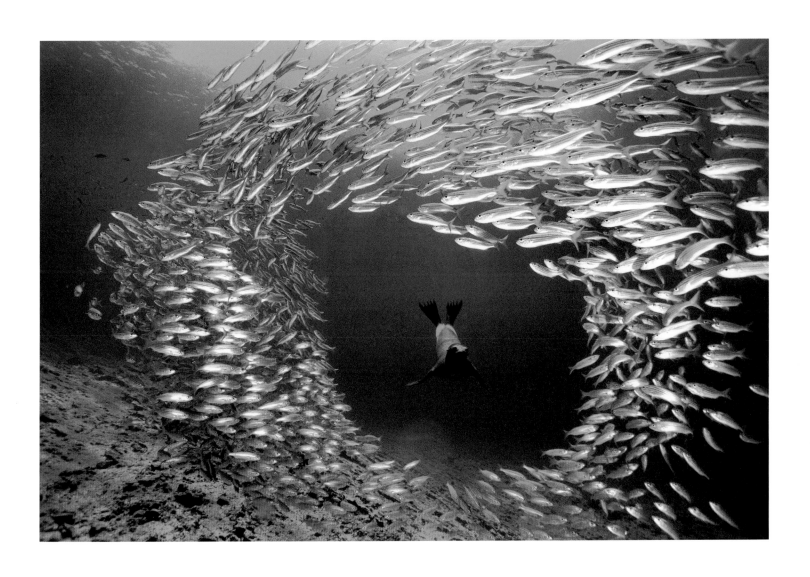

ELLIOTT ERWITT

American photojournalist Elliott Erwitt has produced a witty, beautifully observed body of work covering a wide range of subjects, but dogs remain a constant source of inspiration. He finds amusement in the dogs' behavior and expressions, but he also uses them to provide an ironic comment on people, especially their owners, to whom they often seem to bear an uncanny resemblance.

'**Humor** is important to me and most dogs do have a sense of humor,' he insists. 'They are like people, but with more hair. However, the sense of humor depends on the breed. Smaller dogs such as Terriers are absolutely funny, but some other breeds are deadly serious.'

'Felix, Gladys and Rover' is arguably his best dog picture from the many thousands he has shot. It shows the paws of a Great Dane, stretching out of the frame, together with a comparatively tiny Chihuahua dressed in a knitted coat and hat. Between them are the unseen owner's stylish boots. Erwitt's choice of a ground-level viewpoint serves to emphasize the huge disparity between the dogs' sizes. The final element that clinches the picture's 'classic' status is the understandably overawed and timid expression in the Chihuahua's eyes.

While such sights are obviously a rarity, Erwitt maintains that you find these subjects by training your eyes to look for them. 'Taking pictures is just a matter of **observation** and trying to get what you observe in some logical plastic form,' he says. 'It's not brain surgery. What you do need is some kind of visual sense, a sense of the rules of composition and reasonable familiarity with the tools, but nothing more than that. If you just turn on your observing switch, it's amazing what kind of stuff you can see.'

But what makes dogs such an engrossing subject? 'These pictures are not about dogs. They are about the human condition,' Erwitt declares, though there's a mischievous glint in his eye when he says it.

...addictive...humor...observation...magic...

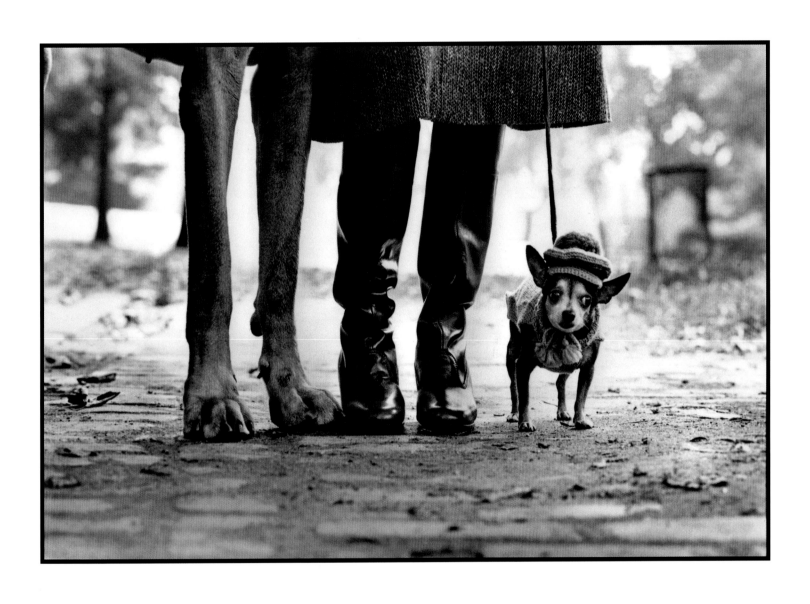

CHIP FORELLI

Outdoor swimming pools, seen while deserted in the winter months, can be a sad and forlorn reminder of a summer that's gone. Yet American landscape photographer Chip Forelli's *Off Season Pool* is filled with a kind of inner radiance. He photographed this scene while exploring a US state park one quiet afternoon. 'Often, when environments are un-peopled for a while, some kind of unintended private **magic** often happens,' he says. 'Such was the case in the pool; it had such a **dreamlike** quality.

'Someone must have thrown the tyres into the pool but when I saw them they had an otherworldly, almost alien presence. They were hovering at the surface and causing circular, light-toned refractions on the bottom of the pool. The location of the pool, flanked by wooded hills, and the 'No Diving' sign, all added to the surreal quality of the setting.' To enhance the subject's unreal quality, Forelli used a 5-minute exposure so that the moving cumulus clouds would create a dramatic 'streaking' appearance in the sky.

This ability to seek out beauty in apparently unpromising subjects is a central theme in Forelli's work. In some of his other images, cooling towers, pipelines, oil rigs and power lines are all conjured into sleek and elegant objects. He says that they all possess what he calls 'unrevealed beauty' and his mission is to reveal it through expressive photographic prints.

'This beauty surrounds us,' he says. 'People just don't take the time, or have the time, to stop and really look at things because we're all so busy. It may be discovered in overlooked or underestimated things, such as a group of plants coming through moss – something people might normally step on. If you're in the habit of looking at things carefully, which I am, then finding these special moments, these little visual gifts as I call them, is tremendously rewarding.'

…observation…magic…dreamlike…unexpected…

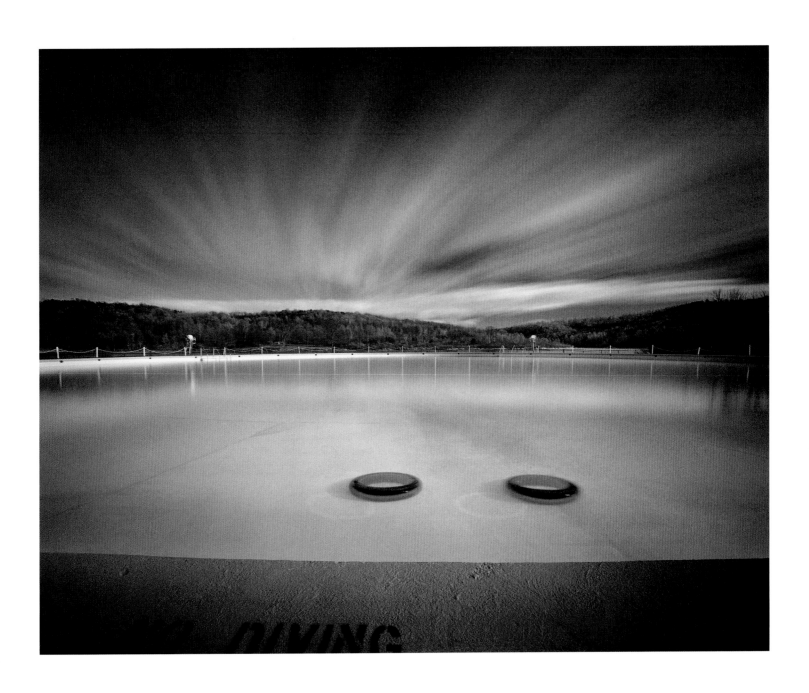

MARTINE FRANCK

Belgian photographer Martine Franck's documentary work employs the same innate sense of timing and composition found in current affairs reportage. She uses these abilities to offer quiet observations of people in everyday situations. Her work's life-affirming quality comes from the genuine empathy she feels towards her subjects. She says she is driven to take photographs by her 'innate sense of curiosity about the world in general' and from it derives 'a way of finding my own identity through other people'.

She has a great ability for recording a momentary gesture, movement or expression that crystallizes a situation or illuminates a personality. These moments often come as a surprise and Franck has said that photographers should be 'constantly on the alert, ready to acclaim the unexpected'. She defines the **unexpected** as 'a moment of joy, of anger, of compassion, or it can also be an element that brings together the whole composition of the image and not only takes you by surprise, but the spectator as well.'

Franck's photograph of a young Tibetan monk and his tutor is one of her favorites from over 40 years of photography. It's a warm and uplifting image and records a fleeting occurrence that could easily have been missed. 'I was being shown around the monastery by Marilyn Silverstone, a former Magnum photographer who had become a Buddhist nun,' she recalls. 'We slipped into the young monk's room to photograph him reciting endless mantras to his teacher. The pigeon was already in the room – they were all over the monastery.

'All of a sudden the pigeon perched on the older monk's head amidst roars of laughter from the young boy. The situation lasted an instant and I was fortunate enough to be in the right place at the right moment with the right lens on my camera. At the time, it was **instinctive**, but when I look at it now it symbolizes a feeling of trust, hope and humor between the two generations.'

…dreamlike…unexpected…instinctive…signature

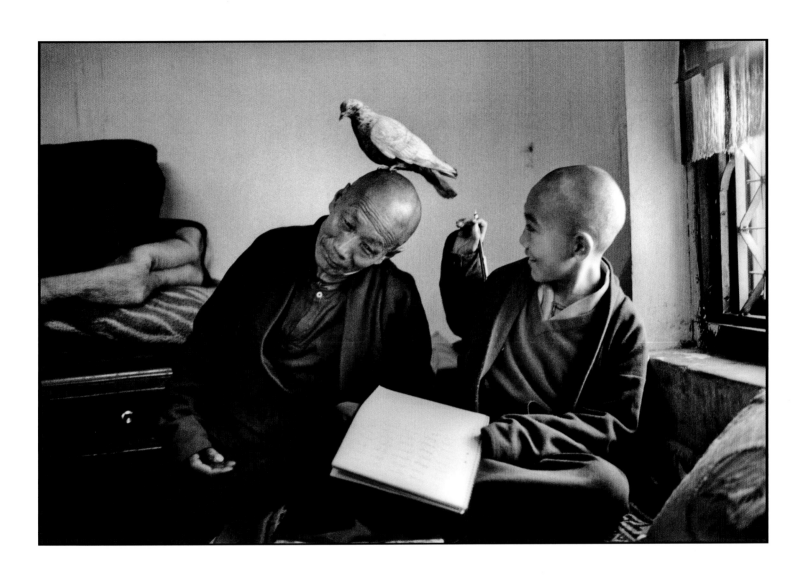

Tulku Khentrul Lodro Rabsel with his Tutor Lhagyel in the Shechen Monastery | Bodnath, Nepal, 1996 **45**

RALPH GIBSON

Looking at American fine art photographer Ralph Gibson's work is like entering a strange, self-enclosed world. His images are atmospheric and enigmatic visual riddles whose power defies easy explanation. They often focus on ordinary objects – a shirt, items of cutlery, the back of someone's head – yet Gibson invests these subjects with mystery, intensity and even menace.

'My intention is to make my perception of anything become the subject itself,' he says. 'I aim to make photographs that have no beginning and no end.' He believes that photographers should aim to develop a unique vision of the world. 'It's important to have your own visual **signature**, something that enables the viewer to instantly know that this is the work of a specific photographer. It's not about style, it's the way you put an image together. It's our own personal way of perceiving our own individual reality. Photography is an unusually amorphous medium in that all you really are doing is releasing the shutter. However, the structure of the medium rests within the intelligence of the eye.'

Gibson's photograph titled *Upside-Down* Glass from his book *Days at Sea* simply concentrates on a café table, outdoors in bright sunlight. A light breeze momentarily lifts the white paper table-cloth. It's an everyday sight, yet a palpable visual tension is created in the texture of the material at the bottom of the frame and the deep black shadow area at the top.

The appeal of Gibson's photographs derives more from what is withheld than from what is revealed. 'For me, photography is a **subtractive** process,' he says. 'If you're making a drawing, you add lines until you've finished, so that's an additive process. If you're making a sculpture out of marble, you subtract and keep chipping away until you have what you want. In the same way, in a world of infinite possible objects to photograph, I eliminate everything I don't want in a frame until I'm finally left with what I do want.'

...instinctive...signature...subtractive...patience...

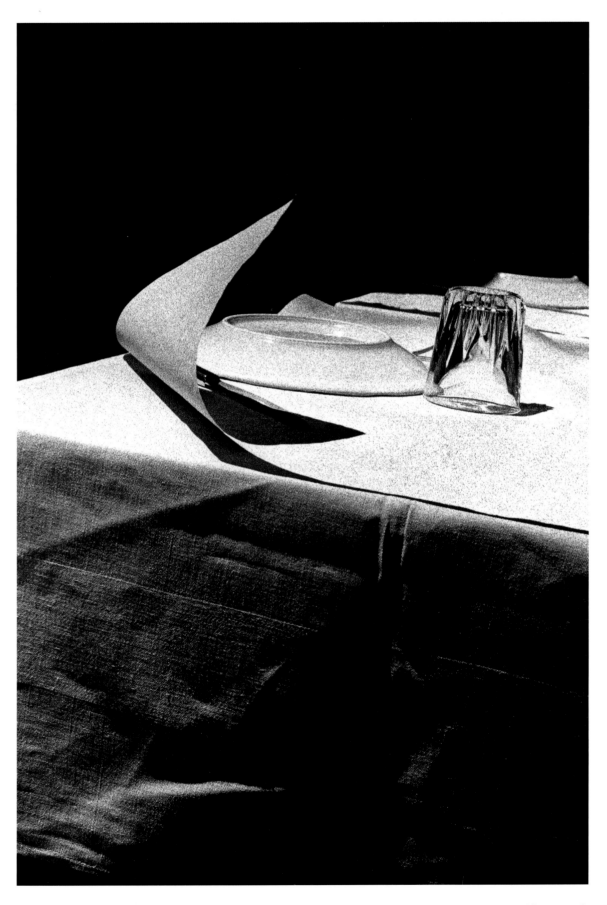

JOSEF HOFLEHNER

Josef Hoflehner's landscape work incorporates natural and man-made elements into luminous images that evoke a sense of space. His portfolios are as likely to reveal hi-tech modern cities as near-featureless wide-open vistas. 'I love to travel, to see, and photograph the most extraordinary landscapes out there,' says the Austrian photographer.

'I especially love to photograph by the sea or in wide open plains, where one can see the horizon unimpaired. However, it does not always have to be the perfect combination of light and atmosphere to make a good image. The photographer needs the skill to 'see', but I think it's also about improvisation, flexibility and **patience**.'

Hoflehner mainly works with a Hasselblad SWC designed in the 1950s and shoots in black and white. Monochrome allows him the creative control he needs and enables him to take a further step away from reality. 'To me, color photographs are often a photographic copy of the landscape, while with black and white I'm able to show the world my vision,' he says. 'I'm able to work with contrasts and **interpret** much more in the image itself.' The portfolio of images he produced while traveling through the State of Florida shows this personal vision at work.

These spare, moody images are far removed from tourist brochure images of the 'Sunshine State'. The image shown was made while Hoflehner was driving through the Everglades National Park and saw intriguing signs warning of smoke ahead. 'A minute later, I stopped on the middle of the road, grabbed my camera from the back seat, and made the shot,' he says. 'It was done in a few seconds.'

The smoke was caused by a controlled burning program, but Hoflehner's image invests the scene with mystery. By using the stark white road markings to lead the viewer's eye into the billowing cloud, it takes a typical American 'endless road' image and gives it an idiosyncratic twist. 'That's what I like,' Hoflehner says, 'to be a landscape photographer, but not mainstream, just somehow different.'

…subtractive…**patience…interpret**…culture…

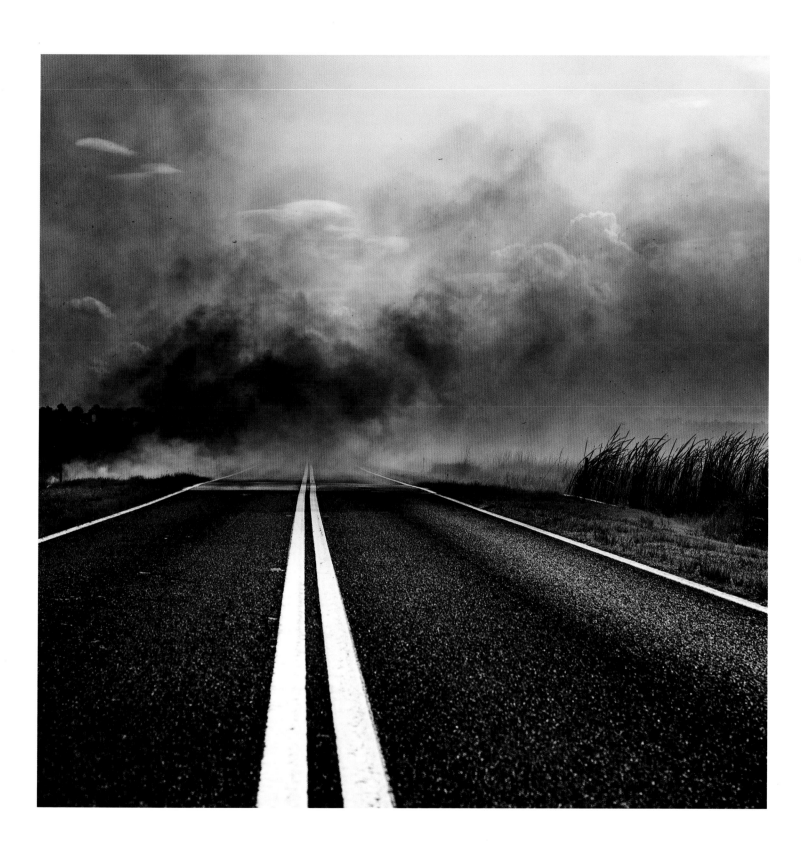

DAVID HURN

Welsh documentary photographer David Hurn believes he has a strong affinity with photography because the medium links well with aspects of his personality. 'One of the reasons I love photography is that I'm very shy,' he says. 'The camera gives me an excuse to be somewhere and I can hide behind it.

'I've also always had an insatiable curiosity, and having a camera allows me to indulge that curiosity – it gives me a genuine reason for being nosy about other people's business. So I have this rather contradictory combination of shyness and curiosity, and photography happens to deal with those things rather well.'

Hurn began his career as a current affairs photographer in London during the mid-1950s, but by 1970 was more interested in pursuing personal projects. In particular, he wanted to explore his Welsh homeland. 'I gave myself the task of going back to Wales to try to discover what was meant by the word **culture**,' he says. 'My way of doing that involved wandering about photographing things I enjoyed and seeing what it all added up to.'

Hurn's witty and perceptive observations were published in *Land of My Father*, the first of a trilogy of books on the country. They deal with Welsh national preoccupations, customs and traditions, and the transition from dependence on mining and steel to computer-based, hi-tech industries. This photograph was taken when he attended a raucous hen night.

'Hen nights lend themselves to pictures because you have people laughing and looking embarrassed in the same picture,' says Hurn. 'Visually, that's wonderful; embarrassment and laughter both have a universal appeal and if you get the two together you have a powerful combination.'

Hurn's brilliantly timed photograph captures a key moment during the performance – and the mixture of hilarity and discomfort it has provoked. 'This has become the iconic picture, the one that somehow connects to my **memory**,' he says. 'I think that's what photographers are trying to do – to link to their personal memory of an event. If you've managed to get a picture that fills that slot, you're very happy.'

…interpret…culture…memory…political…

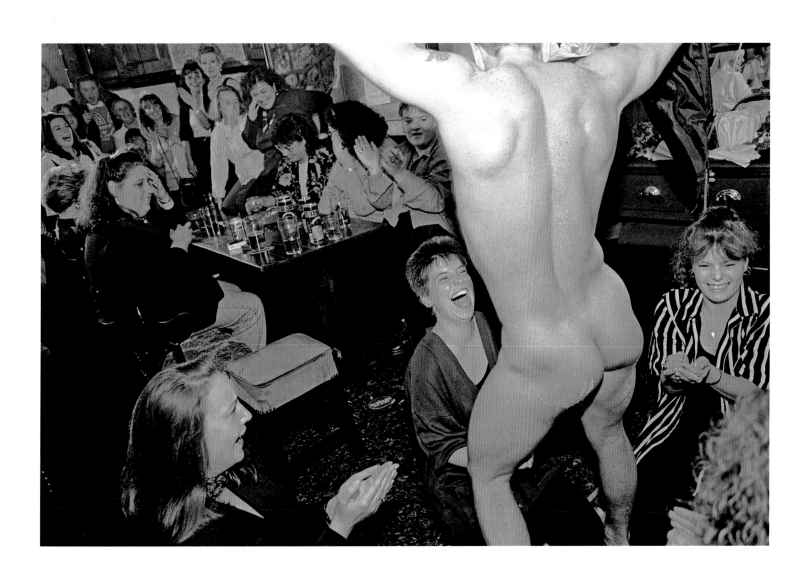

COLIN JONES

English documentary photographer Colin Jones has a simple reason for abandoning his career as a dancer in the Royal Ballet and taking up photography: 'I was driven to do it because I became **political**,' he says. While traveling with the ballet company in the late 1950s, touring countries such as South Africa, the Philippines and England, he witnessed social and political injustice and wanted to make others aware of it. He instinctively found expression in images rather than words and his own working class background gave him an easy rapport with the people he photographed.

'I wanted to **celebrate** working class life,' Jones says. 'My parents were desperate to get out of the working class, but I wanted to get back to it.' Beginning in the early 1960s, Jones worked on photo stories for British national newspapers that documented the daily lives of dockers and miners and street life in working-class communities. In Jones's pictures, manual laborers are shown struggling against the odds – miners drilling at the coal face or dockers waiting for work – but always retain a sense of dignity.

In 1979, Jones was commissioned to photograph a launch at a Dundee shipyard. A launch is normally an exciting spectacle marking the end of a long period of construction, but this particular launch had an undercurrent of sadness. 'I took a series of pictures of the ship as it went down the slipway, shooting from the launch platform,' he remembers. 'What the workers didn't know, though my journalist colleague and I did, was that this was the last ship to be built in that yard. Everyone who had worked on the ship was going to lose their jobs. It was a terrible feeling.'

This is the key image in the sequence. As the huge vessel travels down the slipway into the sea, these highly skilled men are literally watching their livelihoods slide away and float off into the distance. The tiny lone figure waving from the ship, as the workers look on, gives the picture an added retrospective poignancy.

…memory…**political…celebrate…**melancholy…

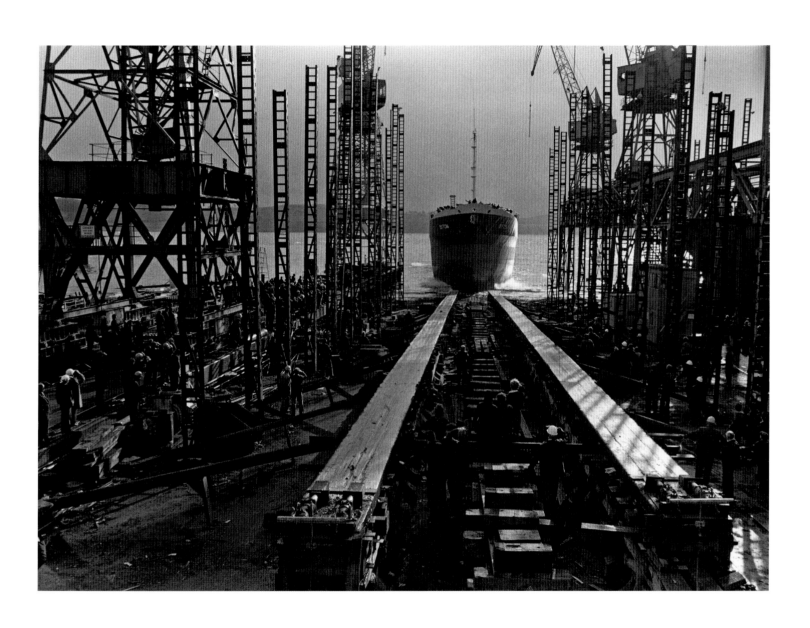

NADAV KANDER

The work of Israel-born photographer Nadav Kander has an austere and unconventional beauty. Whether he's working in the frozen wastes of the Arctic Circle, along the River Yangtze or in Tokyo's 'Love Hotels', his images always have the same sense of coolness and detachment. His inspiration doesn't come from selecting a theme and then working on it; instead it arises from an intuitive reaction to his surroundings.

'The way it usually works is that I notice something around me, some iconography or an atmosphere that I feel in my stomach,' Kander says. 'I see there's something beautiful about a subject, yet not in a pictorial way, and it somehow then wants to be photographed. I think a lot of my work has a sense of **melancholy** about it and that must be part of my inner condition.' Paradoxically, finding the means to express this sense of melancholy is thrilling for Kander.

'I start getting excited at the thought of pictures unfolding in front of me,' he says, 'and when I take a picture I'm really satisfied with, the feeling is exhilarating. It's something I then want again and again. That's the joy of it – making a body of work that starts to inform you about yourself.'

In his series *I Wish I Were Near You*, Kander contemplates the urban landscapes of Los Angeles, which he often shoots at night. He photographed this desolate scene near the airport, where little houses with bars on the windows seem oppressed by the highways passing overhead. 'I was driving around the area, seeing what sets of houses, telegraph poles and stripes would form the iconography I required,' Kander remembers. 'I found it in this scene. I knew I could make a beautiful picture, yet an uncomfortable, **uneasy** picture from what was in front of me.

'It needed a 20-minute exposure. While I was photographing the house, the people who owned it came home and I spoke to them above the deafening noise from the highway. They were delighted with where they lived, as they had moved from somewhere far worse.'

…celebrate…melancholy…uneasy…reaction…

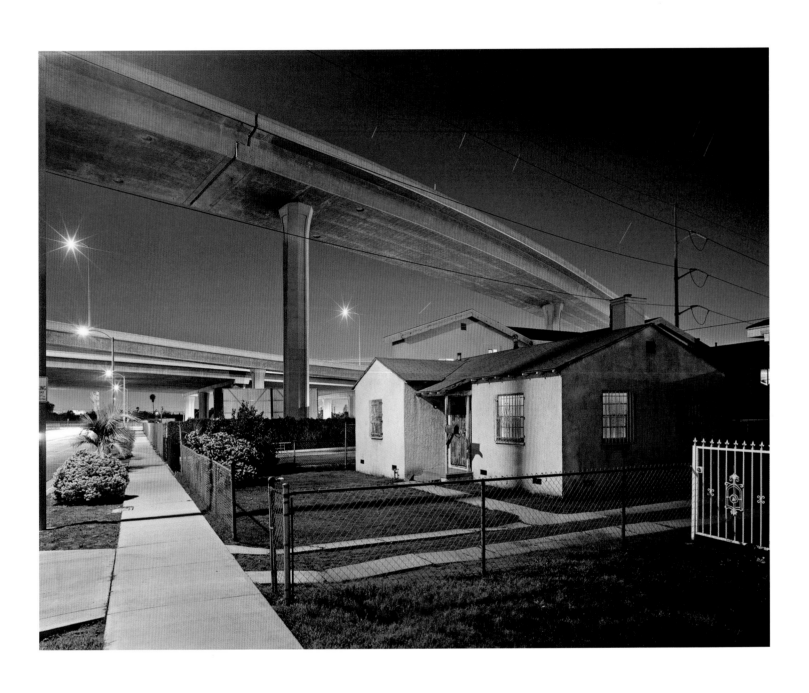

THOMAS KELLNER

German photographer Thomas Kellner's images seem to be motivated by a combination of dedicated artistic endeavor and playful irreverence. Since 1997 he has worked on a series of carefully arranged 'deconstructions' of iconic buildings such as the Eiffel Tower, Brooklyn Bridge and Westminster Abbey.

Initially inspired by Cubist art, Kellner decided to take a building's constituent elements, reduce them to fragments and rearrange them in different ways. At first sight his images look like straightforward photomontages, but closer examination reveals that they are actually contact sheets made from strips of negatives running in sequence. Instead of being a step towards making a print, the contact sheets themselves have become the finished artwork.

'On one level, these images are a **reaction** to mass photography, to say, this is an over-photographed building – don't waste any more time or materials on it,' says Kellner. 'Another reason for doing it is to question the kinds of image we find in contemporary mainstream photography. It has stayed in the tradition of the Renaissance-like window on the world, while fine art has moved on to totally different ideas and horizons.'

When preparing to shoot a particular building, he sketches out how many frames to take, what to include in each frame and which lens to use. Then he determines the best single exposure with a light meter and uses it for each frame.

Kellner's London Eye uses 144 individual pictures to visually explode this popular landmark into a dynamic mosaic of recurring patterns and shapes. He says that his method was dictated by the circumstances in which he photographed the scene. 'The London Eye security guards gave me only 15 minutes,' he says. 'I had to prepare everything in advance, run onto the ground and shoot it as fast as I could, without much control. I think the shooting **speed** is still inherent in the image, and that's what makes the capsules fly so much.'

…uneasy…**reaction**…**speed**…suggestion…

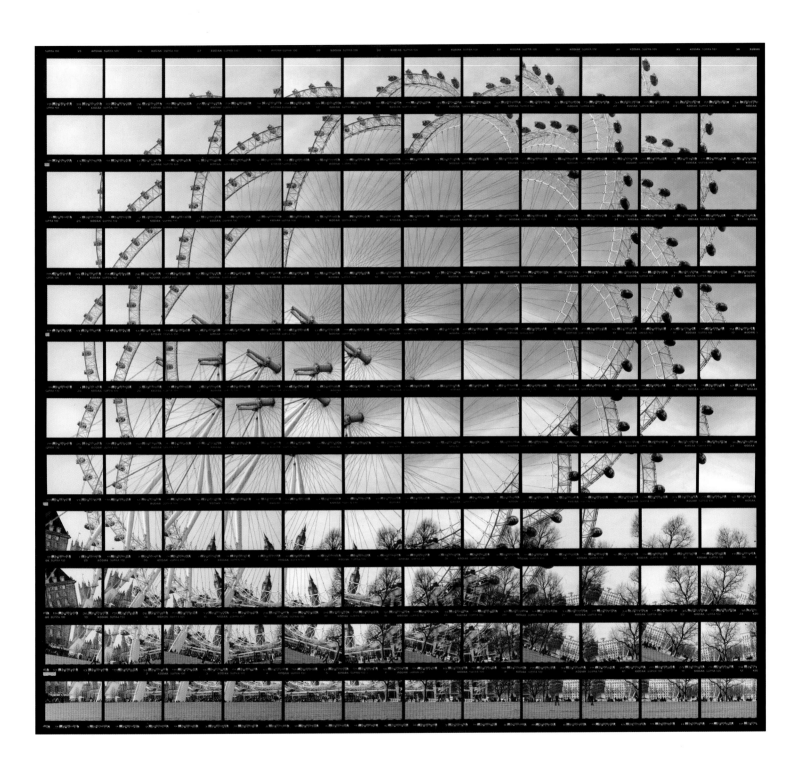

MICHAEL KENNA

English photographer Michael Kenna's distinctive landscape work employs clarity, simplicity and restraint. It's a style he has arrived at intuitively. 'I believe we all see a little differently,' he says. 'Therefore, there should be an endless variety of subjective ways to photograph, based on an individual's background and interests. I find that I am drawn to the idea of **suggestion**, through a small number of elements, rather than to 'description', with a full compendium of information. It's purely personal. I like the idea of a photograph being the visual equivalent of a haiku poem.'

In common with many other landscape photographers, he aims to convey a sense of stillness and contemplation through his work. 'We come into this world alone and we leave it alone and I think it's good to explore solitude and aloneness,' Kenna says. 'I believe, more and more, that we all need the experience of calmness, serenity and grounding as an antidote for fast-paced and sensory-overloaded lives. I would be delighted if some of my pictures enabled that possibility.'

He travels widely in search of scenes that inspire him, but is frequently drawn back to Hokkaido. It's the least developed of Japan's islands and the freezing temperatures in winter give him the opportunity to shoot landscapes transformed by snowfall. In this scene his only subject is the slightly battered fence that traces the shape of a snow-covered hillside. He photographed it early in the morning, using 10-second exposures that recorded the falling snow as a kind of light mist. The experience left him 'freezing, water-logged and ecstatic.'

Looking at the image, Kenna says: 'I like the way the fence moves over the top of the hill and out of view. It allows my imagination to think of what is over there. I also like the two-dimensional black lines on a white canvas. I realize, in this digital world, it is easy to make "clean" images, free of distractions. To actually experience this purity of **abstract** form in the landscape is a distinct and different pleasure — really quite wonderful.'

…speed…suggestion…abstract…contemplative…

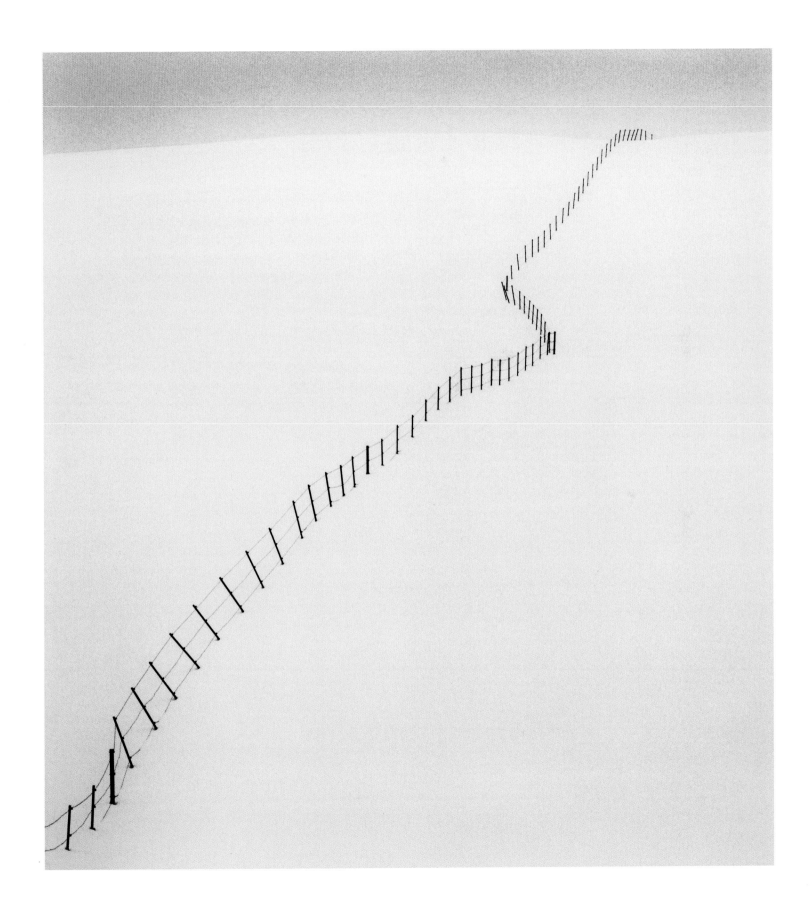

Hillside Fence, Study 2 | Teshikaga, Hokkaido, Japan, 2002 **59**

FRANS LANTING

In the early twenty-first century, when much of the information we receive comes via television and the internet, Dutch nature photographer Frans Lanting believes photography has much to contribute to our understanding of the world. 'I don't think that the abundance of other media diminishes photography at all,' he says. 'In fact, in an age of visual noise, I think photographs have a distinct place as a **contemplative** interpretation of reality.

'If you can create a carefully executed image so that your understanding of the subject comes together with the ephemeral qualities of the moment, it can create something that has more resonance, and can be more enduring, than all those thousands of fleeting impressions.'

Lanting has produced a huge and diverse body of work which concentrates on the natural world and highlights conservation issues. His projects are ambitious in scope and in their use of creative techniques. One example is his book *Jungles*, in which he wanted to communicate 'the feeling of the rainforest rather than the science of it.'

The project includes this vibrant image of a scarlet macaw in flight. To achieve a good vantage point, he set up his equipment on a 60ft high platform in a Peruvian rainforest. For this photograph, Lanting panned his camera with a bird in flight, firing a fill-in flash during the exposure. 'Combining that kind of technical sophistication with the unpredictable nature of these birds, in a remote location in Peru, was a high-wire act,' he says. 'Only a handful of frames expressed this subject in the way I wanted.'

After 30 years as a photographer, Lanting says his dedication to his work is undiminished. 'I remain as curious and as excited about the world as I was when I started,' he says. 'I also have a strong sense of **mission**. I really believe that through my work I can contribute to a better understanding of the natural world. There's never been a greater urgency for us to increase our appreciation for the natural systems that support all life on the planet – including ourselves.'

...abstract...contemplative...mission...compelling...

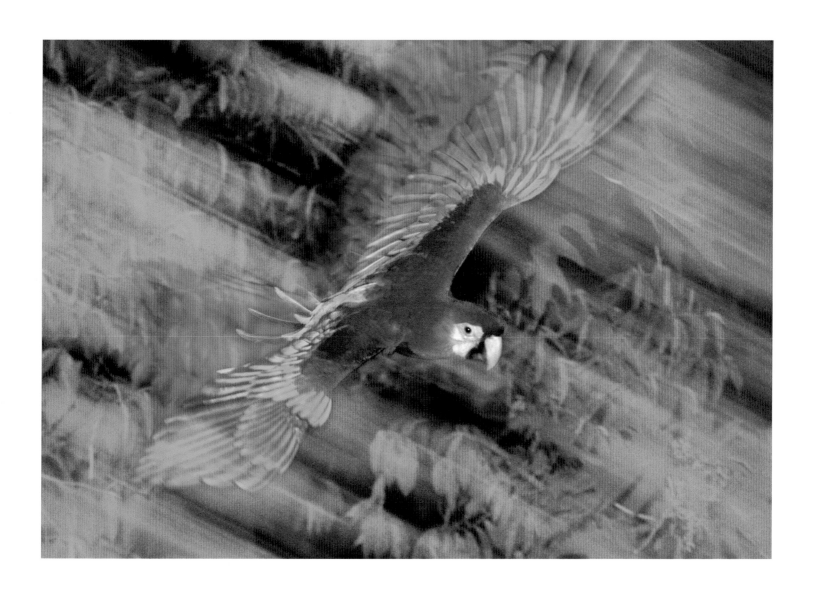

STEVE McCURRY

Steve McCurry's photography is driven by his love of travel and discovering how other people live. 'At a young age, I decided that whatever I did in my life, I wanted to explore this world we live in,' says the American photojournalist. 'I wanted to wander and observe life, and, for me, the journey is at least as exciting and interesting as the photography.'

During his assignments for *National Geographic* magazine, he often photographs the ordinary people he meets on his journeys around the world. 'I tend to photograph people who have something distinctive or **compelling** about their expression,' he says. 'Many of these portraits are the result of chance brief encounters which lasted maybe a couple of minutes from beginning to end.' The portraits allow his subjects' faces to tell their own story; their strength quietly emerges from the sitter's clothes, expressions or gestures.

What makes a good portrait? 'A good portrait is one that reveals something about a person,' McCurry says. 'If a person has had a hard life, it's usually mirrored in their face. Somehow that fascinates me, that you can see someone's personality or life experiences etched into their features. A good portrait must reveal or give some **insight** into a person's condition, or the human condition in general.'

His 1984 portrait of an Afghan refugee, later named as Sharbat Gula, has become one of the most iconic pictures of the twentieth century. The portrait's impact comes almost entirely from her intense eyes, which seem to reflect the rootless and stressful life she has lived. 'This girl had spent her life in the back of a truck,' he says. 'She comes from a brutal country, yet here's a little bit of beauty in all this devastation.'

In 2002, McCurry was memorably reunited with her, after the portrait had achieved worldwide fame and been shown on the covers of several books and magazines. 'I'm really proud of the picture,' he says. 'Regardless of whether you know the story, the picture still has a power to it. There's a haunted quality, but there's also a beauty about it.'

…mission…compelling…insight…trust…

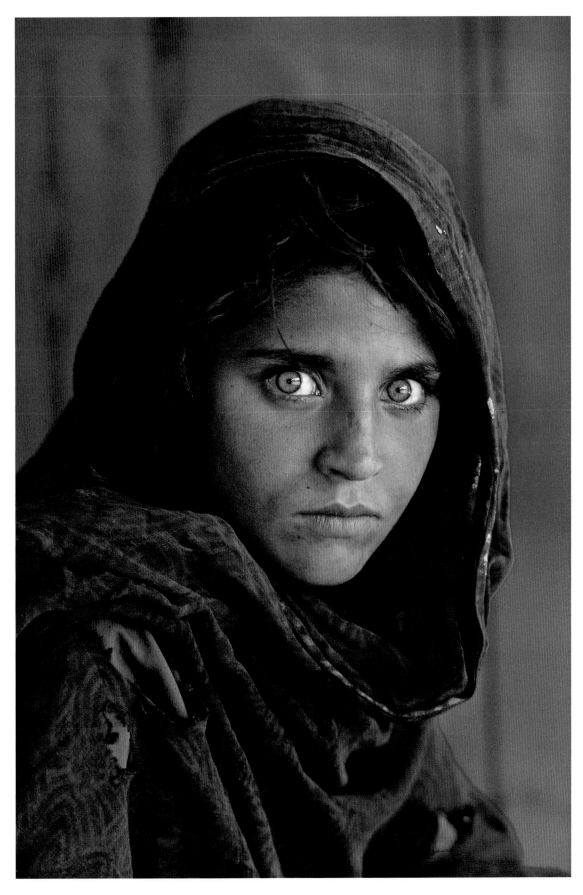

Afghan Girl at Nasir Bagh Refugee Camp | Peshawar, Pakistan, 1984 **63**

MARY ELLEN MARK

Mary Ellen Mark is widely recognized as one of the leading American photojournalists of her generation, focusing her photo-essays on social issues. She concentrates mainly on people who are somehow different from mainstream society, such as circus performers, teenage runaways, transvestites and heroin addicts. Mark photographs them in an unsentimental but compassionate way and engages with them on a personal level. This sense of involvement, of being accepted, is evident in her photographs.

'I am always very open about the way I approach people,' Mark says. 'When I'm getting to know them, I don't hide my camera away, like some photographers; I get the camera out from the beginning, because that's why I'm there. It's a more honest and direct approach. I feel that **trust** is really important, whether you're working with the homeless or with the rich and famous. Your subjects have to trust you. That way, people will tell you about themselves in the pictures.'

The theme of growing up, and particularly children mimicking adults' behavior is a recurring one in her work. 'It's kind of an **irony**,' she says. 'I think of children as adults. I don't make excuses for them.' During one of her assignments for *Life* magazine, Mark was asked to photograph at a school for children with problems.

Her favorite was 9-year-old Amanda and she made a special visit to her home. 'I like that picture,' Mark says. 'Amanda was intelligent but very naughty, with a vulgar mouth. She totally dominated her mother, constantly giving her orders and smoking openly in front of her. At the end of the visit, when I went out back to say goodbye, I found her smoking in the baby pool with her cousin. I took about two frames as she stood there.'

Mark's photograph has the qualities that she herself uses to evaluate great pictures: strong content and excellent design. She captures Amanda's challenging stance as she blows smoke towards the camera, records her precociousness and vulnerability, and draws visual impact from the two girls' contrasting body language and expressions.

…**insight**…**trust**…**irony**…**awakened**…

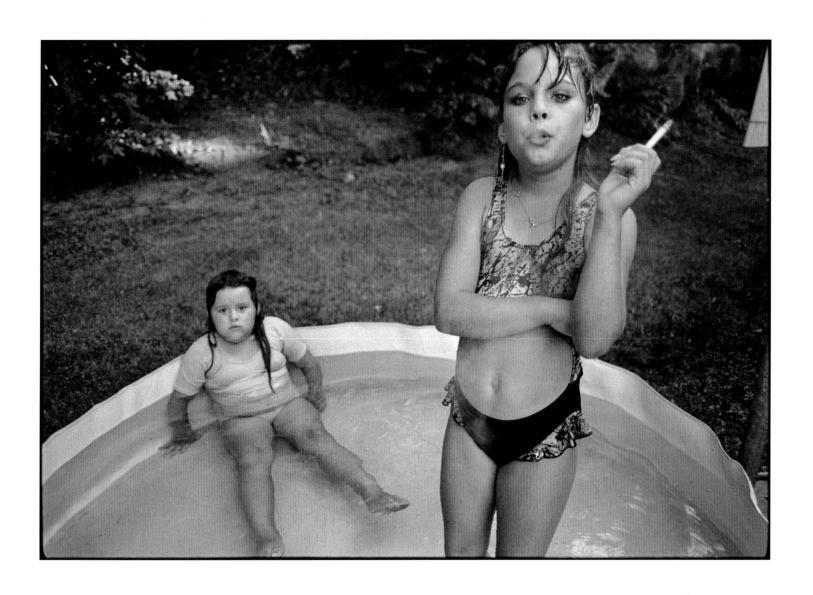

JOEL MEYEROWITZ

When American photographer Joel Meyerowitz is creating his images, he experiences a heightened sensory awareness of the world around him. 'I think most of us go through our lives partially asleep,' he says. 'Even though our eyes are open and we're out in the world, we're daydreaming or we're distracted in some way. But when I make a photograph of something, at that moment I feel in a very precise, conscious, alert, **awakened** state, even if it's only for a split-second. And for me that's the joy of photography: to be connected to things in the world that are suddenly of conscious value.'

His classic book *Cape Light* is an exploration of color, shape, light and atmosphere. Many of the pictures were taken in a relatively small area over two summers around his house in Provincetown, overlooking Cape Cod. 'I was working intensively, touching on landscape, portrait and street life,' he recalls. 'It's as if everything around me offered itself up to observe and **delight** in.' He often repeatedly explored the same viewpoints, transformed in subtle or dramatic ways by different lighting conditions. This image was made when the summer air was charged with a sudden oncoming storm.

'I was drawn out to the porch by the darkening sky,' Meyerowitz remembers. 'It was only about 4pm. I turned on the lights in the house and then there was thunder. I went outside just to stand in the protection of the porch and make a picture of this incredible blue hour that was happening in mid-afternoon. I saw the light from inside and the quality of the blue outside and I thought it was just luscious. I saw the way the open Dutch door related to the horizon and it all made incredible sense.

'When I opened the shutter for about four or five seconds, a bolt of lighting came and I thought, my God, was I lucky or what? I didn't time it, I wasn't trying for it, it was a gift you can sometimes get when you're out photographing – a combination of the formal and the chance.'

...irony...**awakened**...**delight**...character...

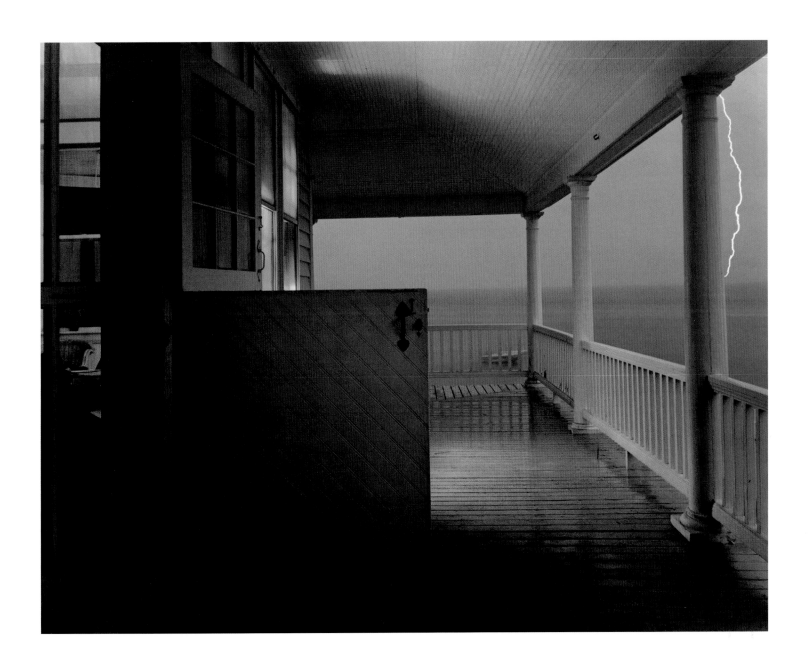

Porch | Provincetown, 1977 **67**

CLIVE NICHOLS

Clive Nichols' flower photographs are an investigation into the myriad shapes, forms and colors of their subjects. As one of the UK's foremost plant and garden photographers, he has worked with a wealth of species, yet regards each specimen as a unique individual. 'I think of flowers as people, really,' he says. 'I approach them in the way a portrait photographer would approach his sitters. I'm looking for their subtle individual qualities and try to bring out their **character** and personality.'

His intense focus on this miniature world brings an increased sensitivity to very slight differences between specimens. 'I look at flowers all the time and reject a lot of them,' he says. 'I don't even think about photographing them if they don't look absolutely right. I'll look around until I find the one that's perfect and then I'll home in on its pattern, texture, shape or color, and work from there.' The flower's appearance dictates the techniques Nichols uses – the way it is lit and framed, the depth of field used and whether it is photographed in color or black and white.

The centre of a rose is a frequently photographed subject but Nichols' treatment of this specimen has given it a monumental quality. Its success is partly due to his decision to remove one of a flower's most prized attributes – its color. Reproducing the image as a duotone concentrates the viewer's attention on the unusual recurring shape of the overlapping petals.

Nichols saw the rose while doing a commercial shoot. 'It was among a lot of other flowers, but when I saw it I got really excited,' he remembers. 'I told everyone on the shoot that I just had to photograph it and took it away. I'd never seen a rose with a **pattern** like that – it reminded me of the blades of a propeller on a boat. That's what you find with flowers – among them all you suddenly see something that's so beautiful or different.'

...delight...**character**...**pattern**...forensic...

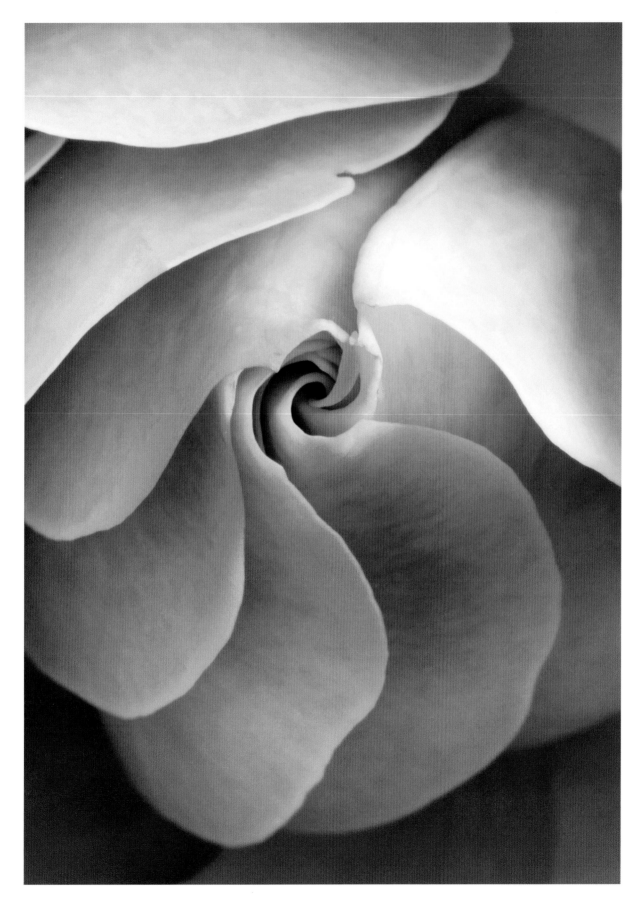

SIMON NORFOLK

English photographer Simon Norfolk uses the medium to understand and depict serious world issues such as the wars in Iraq and Afghanistan, and the aftermath of genocide in Rwanda, Cambodia and Vietnam. 'I choose to use the camera because photography forces an engagement with the real world,' Norfolk says. 'People ask me why I photograph the things I do, but for me the question is "How can you not? Don't you read the paper, don't you turn on the news?"'

'The world is going to hell in a handcart and our liberties are going with it. It seems to me that there's nothing else worth talking about. I don't really choose the subjects I photograph, I think they choose themselves. They walk in and sit down in the armchair and they demand to be discussed.'

Norfolk's approach in his book *Afghanistan: Chronotopia* involves looking at the deep scars a 30-year conflict has left on the country from an almost archaeological perspective. 'Afghanistan has a layeredness, a thickness of history, and if you look you can see these different eras in the conflict leaving different traces,' he says. 'I adopt a **forensic** approach, a kind of unpicking of the layers.'

This image shows the remains of a tea house near a former Soviet-style exhibition of economic achievements in a decimated suburb of Kabul. The balloon-seller was passing by and Norfolk asked him to stand in front of it. Looking at it now, Norfolk says it's a photograph that works on different levels.

'I like the **dualities** in the picture,' he says. 'On one level there's the drabness of the landscape and the vividness of the balloons. But there's a wider meaning because balloons were banned by the Taliban and only reappeared when they lost control of the city. It's ironic that something of that delicacy has survived the war, while the solidity of these great modernist monuments has been shattered to a skeletal ruin.'

…pattern…**forensic…dualities**…empathy…

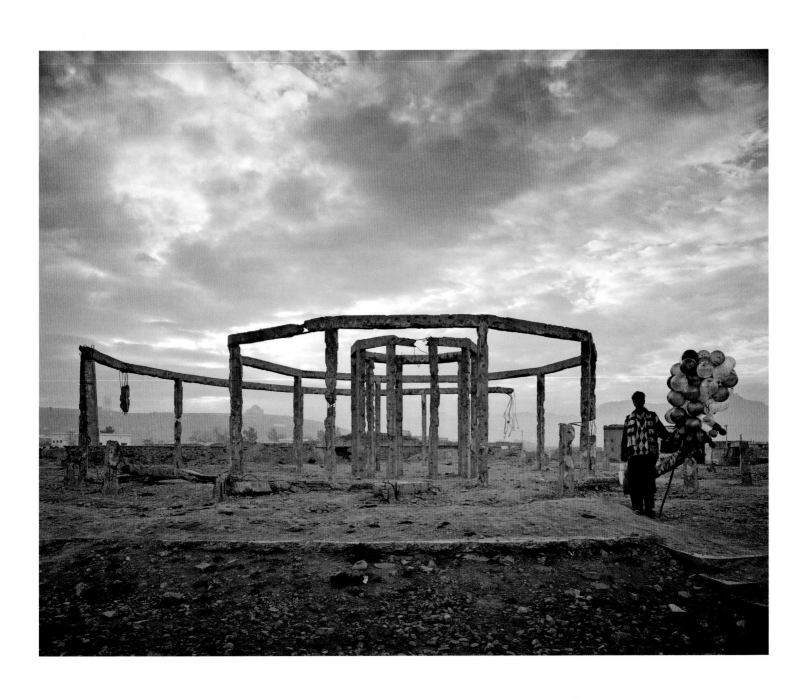

Former Teahouse in a Park next to the Afghan Exhibition of Economic Achievements | Kabul, 2001 **71**

SIMON PARK

Simon Park is an English photographer with a fascination for ancient civilizations at home and abroad; he has photographed sites associated with them in locations ranging from the Isle of Man to Egypt. These dramatic photographs invoke the sense of awe inspired by carved stone monuments and the long-vanished people and cultures that created them.

This striking image shows two of the ancient Moai sculptures on the remote location of Easter Island in the South Pacific, which is over 2,000 miles from the nearest land mass. Park chose to photograph the sculptures at night, so he could use a long exposure and the resulting star trails to achieve his aim of giving 'a sense of monuments enduring in time.'

During the 30 minutes in which his Mamiya 7's shutter was open, Park lit the sculptures individually by walking around them and 'painting with light' by using a few flashgun bursts on each. In the resulting image, the Moai seem to stand resolute and immutable, staring towards the sea. A faint glimmer of light in the sky helps give a sense of scale by separating it from the darker tones of the Pacific Ocean.

For Park, photography is a purely creative medium through which he visually articulates the feelings his subjects evoke in him. 'Before any image is captured, the main thing is to have **empathy** for, or an opinion about, your subject-matter,' he says. 'The emphasis is not on the subject itself, but how a subject is seen. You have to take time to really study it and take in its unique qualities. The drive in me as a photographer is to make those unique qualities permanent.

'Usually, when working with a subject, a particular **visualization** presents itself to my "mind's eye". This might be a very literal rendering of the subject or it might be considerably different, which is often the case with black and white. The technical craft of photography is then applied to achieve a permanent record of this visualization.'

...dualities...**empathy**...**visualization**...experimenting...

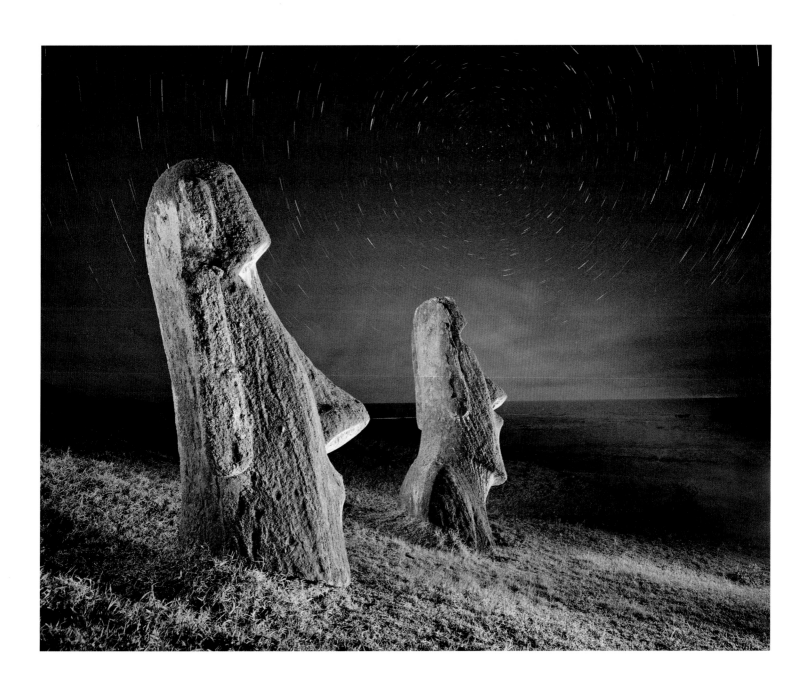

TRENT PARKE

When Australian photographer Trent Parke moved from his home in Newcastle, New South Wales to Sydney, he left his friends and family behind. Feelings of alienation and anonymity permeate the work he produced after moving to the city. 'Sydney terrified me and excited me at the same time,' he says. 'I tried to harness those feelings into the photographs that eventually became *Dream/Life*'. The images in this book, created over a five-year period, often use contrasting areas of dark shadow and bright illumination to produce a strange and unsettling atmosphere.

He achieved the distinctive look of this work through constant experimentation with different techniques and pushing at the boundaries of what can be recorded photographically. Sometimes this process brought surprising results. 'I was **experimenting** and combining harsh sunlight with slow shutter speeds,' he says. 'In one negative I noticed a single shadow/silhouette on a white car that seemed to be still even though the car was a blur. It couldn't be seen with the naked eye – it was something that only could be **revealed** through photography.'

Parke wanted to take the idea further and repeatedly returned to the same place at the same time of day. 'The eventual photograph was taken at rush hour in late afternoon sunlight for 3–4 seconds,' he says. 'It was reliant on the weather, the right amount of people in the right place and the traffic – a lone white bus in peak hour.'

The picture shows the after-image of the bus as it traveled through the frame. The imprinted shadows of people waiting on one side of the road tower over the figures on the other side. It's an interesting technique in itself, but Parke uses it to generate an ethereal or even apocalyptic atmosphere. 'I wanted something that had references to an explosion, a bomb going off in the city environment,' says Parke. 'Otherwise, it's just a moving bus.'

…**visualization**…**experimenting**…**revealed**…**recognition**…

MARTIN PARR

Most people wouldn't like to appear in a picture by English photographer Martin Parr. Distinctive in their bright colors and sharp, wryly humorous viewpoints, his images highlight the idiosyncrasy and oddity of human behavior. Travel and tourism is often a vehicle for his work. The photographs in his book *Small World* show tourists being herded around as if they were sheep or, as in this picture of sightseers at the Leaning Tower of Pisa, behaving like sheep and copying others.

Parr has been accused of patronizing his subjects, but his admirers argue that criticism is directed at society in general and not at individuals. He himself insists that he fundamentally likes people. 'People are very funny,' he says, 'there's no question about that, and without the ability to find these things amusing, they would be too depressing. The laughter my photographs provoke is the laughter of **recognition**.'

He says that his *Small World* images are about the contradiction between the 'myth and reality' of tourism. They have been shot using Parr's favored combination of ringflash and daylight, which gives visual impact and somehow highlights the artificiality of his subjects' behavior. 'These pictures are about the idea of a place and the actual reality of what it's like when you get there and find that there are hundreds or thousands of other people trying to do the same thing as you,' he says. 'Tourism has an upside and a downside. What I'm trying to show in these pictures is that **ambiguity**, because I believe it's both good and bad.'

Parr says his images don't come easily. 'You have to be around these locations for a long time, sometimes all day,' he continues. 'You have to know where to find the hot spots, where you're going to find congestion, and look for the extreme. You have to watch and wait until these moments happen, and often take a lot of very bad photographs in the process.' The best of these images provoke a knowing smile while simultaneously revealing uncomfortable truths about ourselves.

...revealed...**recognition**...**ambiguity**...witness...

PAOLO PELLEGRIN

Italian photojournalist Paolo Pellegrin's reportage lies within the humanistic tradition established by Henri Cartier-Bresson and Robert Capa. Although he uses digital equipment, his images have the same classic black and white appearance as this earlier generation of photojournalists. 'I choose the abstraction of black and white because it helps convey symbols and ultimately meaning,' he says. 'By removing visual information, you have the possibility of skipping a part and going directly where you want to go.'

He takes an unflinching look at the human consequences of wars and natural disasters, but rejects the idea that photographers should be dispassionate observers. 'I have a hard time being a neutral spectator and don't know if I even want to be one,' Pellegrin says. 'You really aren't distanced from what you're seeing, because you're there as it's happening. At the same time you're there with a function, however imperfect the function may be. Part of this function is to be a **witness** and to communicate.'

He's sensitive to the inherent conflict between making the world aware of people who are suffering from the consequences of war and natural disasters, and allowing them their private space. 'In my work, I'm often intruding in extreme and delicate circumstances, so every time I have to push myself to actually shoot and work,' he says. 'I do it because I think there is a reason for it, to send a **signal** to others. That's what drives me.'

Pellegrin's images evoke an emotional response partly due to the shocking or disturbing events he's witnessing at close hand. The impact is sometimes heightened by the techniques he employs. This photograph shows a Palestinian woman mourning her son, killed in the ongoing conflict with Israel. Pellegrin has given it an emotive, impressionistic quality through creative use of motion blur; the picture itself becomes a visual expression of the woman's disorientation and distress.

...ambiguity...witness...signal...epic...

MARK POWER

In his many long-term documentary projects, English photographer Mark Power avoids using in-camera or post-capture digital tricks to artificially accentuate his work. His photographs simply record the things that interest him, with the clarity and precision available from large-format camera equipment. 'I don't dress up my pictures in unnecessary technique and I'm not interested in a drama imposed by filters,' Power says. 'Actually, I'm not too interested in dramatic pictures at all. But I am interested in **epic** pictures. There is a difference.'

He is driven to the documentary genre by his need to record and preserve the world around him. 'The world is fascinating enough as it is,' he says, 'and since it is constantly in flux, the subject is constantly being refreshed. I also think it's important to record our times for the future. I want my children, my grandchildren, to know what the world once looked like.' This motivation lay behind one of his best-known projects, in which he documented the construction of the Millennium Dome.

Power photographed the project over a four-year period, from its beginnings on a toxic former industrial site in East London to the grand opening on the eve of the new Millennium. Despite the political controversy that surrounded the project, it was a spectacular feat of engineering and Power displays a fascination for everything about its construction, from the hi-tech roof to discarded nuts and bolts. Most of all, he communicates the grand scale of the structure, as shown in this image. The high viewpoint and bright sodium lighting give the scene a stunning clarity and capture a still, silent pause during the frantic race to complete the Dome on time.

While the resulting book, *Superstructure*, initially sold few copies, it has become one of Power's most popular books. 'I think this is because the political issues have subsided and the work is now of **historical** interest instead,' he says. 'Looking at the book now, I think it does stand up as a historical document, which is what I wanted to achieve.'

...signal...**epic...historical**...identity...

STEVE PYKE

English photographer Steve Pyke is drawn to explore the human face and his portraits record every texture, wrinkle, hair and blemish. They also capture something unique to that individual: their story. 'The human face signals our emotions, suggests our cultural background,' he says. 'It is the naked part, that we present to the world and our faces speak reams about our **identity**. Our faces change with time, absorb the passage of time and we tell our stories through our faces.'

For Pyke, photography is 'an investigation into the nature of being' and his trademark style is to fill the frame with the sitter's face. He uses Rolleinar close-up attachments on his fixed-lens Rolleiflex camera, and places it very near to the subject. 'I rarely look into the ground glass of my camera except to momentarily check composition,' he says. 'I engage my sitters and at certain points in our conversation I will photograph. Most of my frames are made looking at and interacting with my sitters.'

Pyke often avoids using a sitter's home or workplace as part of the image and simply uses a black background. The combination of the black backdrop and the concentration on the face produces strong and very personal portraits. 'When I first used this approach, being able to focus so closely and the **intimacy** of that situation seemed a revelation to me,' he says.

This photograph is part of Pyke's series on World War I veterans, made in the early 1990s. Even though the war itself had been only a small proportion of these men's long lives, most had been involved in major battles and had taken a lifetime to come to terms with their experiences. In this image, French war veteran Emile Richard is shown in profile, looking thoughtfully away. He was badly injured in the war and had been unable to work throughout his life. By isolating Richard's face during a moment of reflection, Pyke's touching portrait conveys dignity and a sense of sadness.

...historical...**identity**...**intimacy**...surreptitious...

HUMPHREY SPENDER

The English documentary photographer Humphrey Spender was brought up in an intellectual left-wing social circle that included his brother Stephen, W.H. Auden and Christopher Isherwood. During the Depression of the 1930s, his compassion for ordinary working class people made him overcome his natural shyness and document them and the desperate conditions in which they lived. At this time, early Leica cameras were enabling photographers to capture everyday life in a way that had never been previously possible. They were small, with quiet shutters and high-quality lenses, though awkward to use in comparison with later models.

However, these expensive cameras were rarely seen in poverty-stricken communities. If Spender was seen taking pictures, it often aroused curiosity or suspicion and it put a barrier between him and the natural behavior of his subjects. 'I felt that if people were aware they were being photographed, they were no longer totally themselves, so I had to be **surreptitious**,' he told me. 'If they were aware of the camera, they always put on a smile and thought about which was the best side of their face to show. So I became completely **obsessed** with the idea that photographs of people were only meaningful if they didn't know they were being photographed.'

Most of Spender's photography was done without his subjects' knowledge. He hid his camera in an old mackintosh or a briefcase with a hole cut in the side for the lens. He would often photograph at football or boxing matches, when his subjects' attention was fixed on an event.

He also avoided notice by shooting from a discreet distance from people, as in this powerful and atmospheric industrial scene. It shows groups of unemployed men walking home along the River Tyne in Newcastle at dusk, after a fruitless day's search for work. The silhouetted shape of the Tyne Bridge, which would have been built by men like these in more prosperous times a decade earlier, looms against the evening sky.

...intimacy...**surreptitious**...**obsessed**...preconception...

DENNIS STOCK

For American photographer Dennis Stock, successful images result from a felicitous harmony of planning and discovery. 'You approach subject-matter, I believe, with two attitudes,' he says. 'One is **preconception**, which gets you there physically, and the other is **improvisation**, which allows you to discover. Both attitudes must prevail; you do your homework and see what happens. My pictures are sometimes posed, sometimes not. What's important about a picture is that it has a sense of honesty about it.'

His famous photograph of James Dean was posed to the extent that he took Dean, then a rising Hollywood star, to New York's Times Square and photographed him as he walked towards the camera. It was an appropriate location as it featured the awnings of the cinemas in which Dean aspired to star. Yet the photograph wouldn't have become the definitive image of Dean if an unexpected shower of rain hadn't started to fall during the shoot.

Stock made a virtue of the situation and used his reflection in the raindrop-spattered puddles as a key part of the image. These elements are given greater prominence by the slightly misty conditions, which have rendered the background in paler shades of gray.

The resulting picture suggests a lonely and embattled young man. Its melancholy atmosphere is accentuated by our retrospective knowledge that Dean was a charismatic film star who died tragically young. 'The picture works because it shows two symbols, not one: James Dean and Times Square,' Stock says. 'As a Hollywood portrait, it's extremely peculiar because it's unusual to have a movie star who is that small in the picture. The implication is that I didn't photograph him as a movie star; here the surroundings are as important as the star.'

Stock also believes that one other tiny element completes the image. 'When you look at the picture, your eye goes to the cigarette in Dean's mouth,' he says. 'If the cigarette wasn't there, it wouldn't have worked.'

…obsessed…**preconception…improvisation**…symbolic…

James Dean in Times Square | 1955 **87**

TOM STODDART

It's often said that people in the West have seen so many pictures of Third World famine victims that they no longer respond to them. Yet English photojournalist Tom Stoddart's image, shot at the epicentre of the 1998 famine in Ajiep in Southern Sudan, remains both moving and shocking.

Stoddart photographed this scene while he was working alongside the charity Médecins Sans Frontières. 'The situation in Sudan was really desperate,' he remembers. 'This particular incident concerned a boy who was crawling along the ground with a bag of maize. I was making pictures of the scene when a guy walked past me, stole the maize and left very quickly.'

His picture captures the moment and the starving boy's hopeless but disdainful look. It shows the man holding the maize in one hand and a stick in the other. Stoddart's decision to frame it without showing his face gives the image a wider significance. 'It is **symbolic** of what happens every second in Africa and other Third World countries,' he says.

'I have been criticized for not intervening, but in this situation, photographers are faced with this dilemma all the time. My job is to bring back telling images. This one moved people and still does, and so I did what I was there to do.' His photograph achieved something far more effective than he would have done by intervening in an individual incident; its publication directly resulted in £100,000 being immediately donated to the famine relief charity.

Stoddart's distinguished career has included photographing many wars, famines and natural disasters and his work demonstrates the continuing importance of photojournalism. 'I'm motivated to do it by a combination of **anger**, compassion and curiosity,' he says. 'I think that photojournalism is a really privileged existence and gives us the opportunity to say, 'This is what's happening in the world. Look at it. Shouldn't we change it?'

…improvisation…symbolic…anger…surprise…

MATT STUART

Englishman Matt Stuart is one of a new generation of street photographers whose images capture life's oddities and chance ironies, often through unexpected visual juxtapositions. He has an almost obsessive dedication to his work, never goes out without a camera and has photographed street life every day for the past eleven years. For Stuart, street photography is ultimately 'about making sense of society and my place within it.' The pleasure and entertainment lies in its unpredictability.

'I like the feeling of absolute **surprise** when I see something happen in front of me,' he says. 'There's nothing you can do, arrange or set up, it just happens or it doesn't. The only control you have is obviously where you put the frame around what you want to photograph. You can be lucky for a week and then unlucky for three months, and you have to deal with that. You just never know what you're going to find when you go out. That's the **drug**: the need to know what's going on and the feeling that you should be out there photographing it.'

Walking on his regular route along London's New Bond Street one day, he noticed a poster advertising a new jewelry shop, illustrated with a peacock's neck and head. Over a period of several months, he photographed it apparently emerging from different vehicles. Then one day he saw a builder's skip in the perfect position, covered with matching blue tarpaulin. The two elements were completely incongruous yet looked oddly appropriate. His picture was complete.

'I liked the collision of these two worlds,' Stuart says. 'A jewelry merchant has set up this expensive advertising hoarding, but then some builders have come along and dumped their skip in front of it. I photographed it with people walking past, but they somehow imposed on the subject. I like the fact that this picture doesn't contain any people, but that people have been its unintentional creators.'

…anger…surprise…drug…intriguing…

WOLF SUSCHITZKY

Wolf Suschitzky fled Fascism in Europe in 1935, emigrating to England from his native Austria. His documentary work in the 1930s and '40s gives us an outsider's insight into British life. It records people from a range of social classes, including smartly-dressed people browsing in bookshops in London's Charing Cross Road and those living in the squalor of Dundee slums. Suschitzky's work shows a natural ability for composition and timing and his style is both compassionate and gently inquisitive.

This photograph resembles a still from a long-forgotten film and is part of a wider personal narrative that we can only imagine. The woman is directing an unsmiling, searching gaze at the man, who seems to be deliberately avoiding her eyes. It appears a tense moment in a very English argument, taking place in the restrained and polite surroundings of a London café.

Suschitzky remembers that he was having tea in a Lyons Corner House when he noticed the couple sitting at the next table. 'They were **intriguing**,' he says. 'She seemed to be giving him a hard time. While they were involved in their conversation I carefully positioned my Rolleiflex on the table and waited. I kept looking sideways into the glass focusing screen so that I didn't seem to be observing them. I only took one picture.'

The composition is unusual and appears deliberate. Although the focus is on the left of the frame, the other diners on the right, the pillar in the centre and the symmetry of the arches overhead give it perfect balance. Was this composition a carefully worked out and conscious choice? 'No, I had to do it quickly, so as to not draw attention to the camera,' Suschitzky says. He adds with characteristic modesty, 'There's a lot of **luck** in documentary photography. This was just luck.'

…drug…**intriguing**…**luck**…elegant…

JOHN SWANNELL

English photographer John Swannell has returned to the subject of female nudes throughout his career. In some pictures the models are shown as physically powerful and sexually provocative, while in others they appear aloof or dreamily detached. Women's bodies are also sometimes used as part of abstract and sensual studies of texture and form in natural landscapes or studio set-ups. One thing never changes: Swannell's images are always primarily a celebration of feminine beauty.

'I aim to make women look **elegant**,' he says. 'I always loved the fashion photographers of the 1940s and '50s, people like Horst P Horst and Richard Avedon. They photographed women in a stylish and beautiful way. Maybe elegance is a bit old-fashioned now, but it's just the natural thing for me to do.'

He acknowledges that it's easy for nude images to go beyond the elegance he wants to portray. 'It's a very sensitive area,' he says. 'If you're working with beautiful women, you can go to the very edge of the precipice to produce a strong image. If you go beyond that, it easily becomes erotic or pornographic. Sometimes people look at my pictures and say I've pushed the barriers too far. For me, it's about producing images that stir people. I love to see people's reactions when they look at my photographs.'

Swannell's polished and sensual studies look as if they have been slowly and meticulously crafted, yet he says he works 'quickly and mainly by instinct.' When working on his 'Dasha in Cumbria' series, Swannell traveled around the Lake District with his model. In one location he found a gnarled tree with tough, twisted branches which accentuated the smooth, almost luminous quality of the model's skin. 'We just played around and did a whole series of pictures in a couple of days,' Swannell remembers. 'This is one of my favorites. It's unusual and very **romantic**, which is what I like.'

...luck...**elegant**...**romantic**...distance...

DENIS THORPE

The photojournalist Robert Capa famously declared, 'If your photographs aren't good enough, you're not close enough.' Yet English photographer Denis Thorpe has made a virtue of not going too close to his subject and allowing it space in the frame. 'When I worked for *The Guardian* I had the freedom to step sideways and try something different, to take a more considered look at a subject,' he remembers.

'If there was a chance I always tried to do something of my own, often shooting from a **distance**, though it was more difficult to get pictures away from the main group of press photographers. It wasn't always possible to do and sometimes you'd only get one shot.' The luxury of taking a little more time over his pictures enabled Thorpe to construct them with thought and artistry. His images have a pictorialist quality that has made them memorable, even if some of the news events that inspired them are long forgotten.

His photograph of a wintry Hebden Bridge was shot to illustrate a story on the difficulty of getting mortgages on certain types of houses. It amply fulfilled the brief, but it doesn't look like a news picture. Other photographers may have chosen a less subtle approach, but Thorpe chose a position on a hillside overlooking the town. He was attracted to the way the snow emphasized the shapes of the houses and buildings, so set his camera on a tripod and waited for the right light. 'I mainly loved photographing people and being with people, though this picture works because it is all about **geometry**,' he says.

'However, when I saw this beautiful scene, the light was too flat. I told the reporter that I'd wait until I got some really good light. I had to have patience. Then late in the day there was that glimmer you get just before you lose the light altogether. It gave me an extra bit of contrast and that just made the picture. It was a joyous moment.'

...**romantic**...**distance**...**geometry**...**dialog**...

CHARLIE WAITE

In January 2002, English landscape photographer Charlie Waite was exploring the landscape of the Picardie region of Northern France by car when he came across a small wood beside a road outside Amiens. It was flooded as a result of heavy rainfall in previous weeks. However, the scene wouldn't have arrested Waite's attention without the combination of a number of elements.

'If I had passed it by without seeing that charming unobtrusive sky and the bright sunlight making the bark appear silver, I wouldn't have stopped,' he remembers. Looking more closely, he saw that the still water was creating a mirror-like reflection, and his fortuitous timing resulted in one final element that completed the picture. 'What really made it work as a picture was the fact that the water was receding and had left little dark wet belts of dampness on the tree trunks,' says Waite. 'I waited for half an hour while the water levels lowered and the belts became more pronounced. They give you an understanding of where the reflection ends and reality begins.' He used a polarizing filter to give a clearer reflection of the trees in the water's surface.

Like many of Waite's photographs, it has a calm but uplifting quality and displays his heightened sensitivity to light, shape, pattern and color. 'For me, the key to a successful landscape image is to fully engage with the subject,' he says. 'It's about having a kind of **dialog** with the natural world – the land, water and clouds and the way the light plays on the landscape. When color, balance, harmony and **design** all come together and interlock, you feel elevated and enriched.

'There are times, when I'm photographing, when I'm perplexed by a landscape; I know there's something there and can't get it. But when it all works – when my antennae are finely tuned and I'm feeling visually agile – it's wonderful. I look at a beautiful scene and think, "I can't allow that to vanish."'

…geometry…**dialog**…**design**…discipline…

ALBERT WATSON

Although Scottish-born Albert Watson is established as one of the world's most successful commercial and editorial photographers, he believes his initial training in the 1960s was essential in forming his current style and working methods. 'I use the **discipline** I learned at art college every single day,' Watson says. 'I'm not a naturally technical person; it's something I had to learn. I started out producing something I thought was brilliant on the day and the next I'd look at it and put it in the garbage. There was a lack of technical fluency to my work. Therefore I saw the improvement of the technical aspects as an aid to the creative, not a suppressant.'

Whether he's shooting a commercial for Chanel, a cover for Vogue, a celebrity portrait or an urban landscape, Watson's work is characterized by its bold, graphic quality and its lack of sentimentality. His images are often provocative, yet keep the viewer at a distance. 'A lot of my pictures are **confrontational** and controlled; they're not observational or voyeuristic,' he says. 'I aim to create something that is strong, powerful, memorable, interesting and technically correct, not lazy.'

This extraordinary image combines all those qualities. Watson's original idea was to photograph Mick Jagger and a leopard together in a Corvette. However the leopard's aggressiveness meant that a Plexiglass partition in the car was essential for Jagger's protection. While it was being built, Watson decided to try a double exposure. 'It was completely spontaneous,' he recalls. 'I photographed the leopard first and drew the position of the eyes on the camera's viewfinder. Then I rewound the film, put Jagger's face in the same position and exposed the film again.

'I thought it wouldn't work and almost didn't develop the roll of film, but I found that almost half the images I shot were in perfect registration. I just happened to get very lucky that the angle of the leopard's head was correct and the two faces had a sympathy to them, so they could meld together. The picture was very simple and consequently became iconic.'

…design…**discipline**…**confrontational**…moment…

ART WOLFE

American photographer Art Wolfe has traveled to hundreds of locations worldwide during his 30-year career, capturing the diverse wildlife, landscapes and cultures he has encountered. Yet while the speed with which he can create photographic images suits his active temperament, he began his career as a painter and approaches photography as a 'free art form'. He aims to exploit its creative possibilities rather than using it for pure journalistic documentation. 'I really don't want to dazzle people with detail,' he has written, 'I want to move them by the **moment**.'

The creative challenge of constantly developing fresh and uniquely individual images is part of what drives him on after 30 years in the field. 'I seek new ways to approach photography,' Wolfe says. 'My work has evolved and I think improved year by year. I always want to create a strong and surprising **vision** of each subject.'

In common with other wildlife photographers, Wolfe uses the medium to make a statement about landscape, culture or wildlife preservation. His goal is to create positive and uplifting images that focus on the unspoiled beauty that the world contains, rather than what has been lost.

Wolfe has traveled to some of the most untamed locations on Earth. His favorite place is the island of South Georgia in the South Atlantic, a remote wildlife haven and home to over 400,000 pairs of King Penguins. 'South Georgia is as wild as it gets, hosting one of the largest concentrations of wildlife anywhere,' says Wolfe. 'Some beaches are blanketed by King Penguin colonies with tens of thousands of birds.' This image shows young penguins moving towards him with endearing curiosity.

Wolfe's low-level viewpoint, together with his use of a small aperture to keep the penguins and their wider environment in focus, have combined to evoke the feeling of being present in the scene. 'The chick, still protected by warm down, approached me without fear,' he says. 'For me, this image represents a direct encounter with the wild, which is a rare and precious experience.'

…**confrontational**…**moment**…**vision**…**poetry**…

TOM WOOD

English documentary photographer Tom Wood creates subtle and compelling images out of the everyday world around him. This photograph is a prime example of his style. Among the passengers boarding or waiting for buses, it singles out a smartly dressed woman who seems lost in thought. The poster behind her displays an idealized world of sunshine and romance, in stark contrast to the mundane reality around her.

The picture is part of Wood's project *All Zones Off Peak*, which he shot while traveling on buses in Merseyside over a 15-year period. What made him photograph this subject so compulsively? 'For me, it's a practical thing,' he says. 'I don't drive, and when I'm traveling on buses or trains I feel I'm wasting time. So I take photographs. I have come from a fine art background where the idea is to explore visually whatever you're interested in, whatever excites you. I use a camera and I use a documentary style, but what I aim to do is definitely closer to **poetry** than journalism.'

Wood's photographs are shot spontaneously and capture an often momentary convergence of people and their surroundings. Images from his bus series are printed full-frame from the negative and show everyday inner-city life in all its banality and clutter. His fellow passengers are shown as pensive, frustrated, uncertain, bored, or simply staring hopefully into the distance. The pictures he has selected from the three thousand rolls he originally shot have an enigmatic quality; even Wood himself finds it difficult to articulate exactly what they are about.

'When I take photographs, I feel I'm trying to capture something that I can't put into words,' he says. 'I always feel I'm asking a **question** every time I put the camera to my eye. Often, I don't know what I am looking for until I see it in the pictures. To paraphrase the American photographer Lisette Model, I'm not trying to prove anything in my photographs, the pictures I take prove something to me.'

...**vision**...**poetry**...**question**...**engagement**...

HARRY CORY WRIGHT

When English landscape photographer Harry Cory Wright approaches a scene, he aims to capture the spirit of a place, its own individual atmosphere. He uses a 10 x 8 camera and the resulting large negative, combined with the more methodical technique it dictates, produces photographs rich in subtle details and nuances. The appeal of Wright's photographs lies in contemplating these details. 'The large-format camera allows for a real **engagement** with what's in front of you,' Wright says. 'I get a feeling of deep calm from using it. I'm looking for magic, the feeling of being right there in the scene and capturing the uniqueness of a point in time.'

Some of his subject choices initially appear a little eccentric: seemingly unremarkable hedgerows, riverbanks or fields of grass. Wright's intention is to draw attention to them, to invite viewers to reflect that what appears everyday and ordinary is filled with shades of feeling and meaning.

Wright's Holly and Beech, photographed in the Wye Valley, which bestrides the border between England and Wales, is a typical example of his work. At the centre is a grand, ancient beech tree and a holly bush in bright, even light. However, he isn't concerned with isolating these elements; they form part of a wider scene that includes woodland paths, a well-trodden muddy foreground and woodland fences.

Some photographers would exclude these traces of human activity in an attempt to present a pure and unsullied landscape. For Wright, however, these elements are all important parts of the real landscape that we experience. 'The photograph is about the mixture of natural world and human encroachment,' he says. 'The paths are human things, underneath this big canopy of nature.

'I'm not interested in "cleaning up" a picture. I want the whole detail, the experience of what it's like to be actually there, in that place at that moment. The paths and the fences, together with the tangled mass of growth and activity, give the feeling of **completeness** that I look for.'

...question...**engagement**...**completeness.**

BIOGRAPHIES

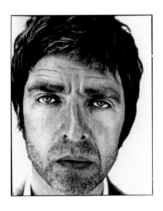

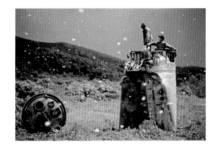

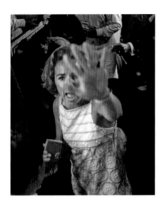

DAVID BAILEY (b.1938)

Bailey took up photography during National Service with the RAF and in 1959 became an assistant to fashion photographer John French. He was contracted to British *Vogue* a year later. His rise to fame was meteoric and he spearheaded a new, informal approach to fashion and portraiture that chimed with '60s culture. Bailey became as well-known as the models, actors and pop stars he photographed. His work has been published in major international magazines including American *Vogue* and *Harper's Bazaar* and he has directed around 300 commercials. He was made a CBE in 2001. He remains a prolific photographer and has a studio in central London.

Books: Bailey's many books include *Black and White Memories: Photographs, 1948-69* (1983), *If We Shadows* (1992), *The Lady is a Tramp* (1995), *Chasing Rainbows* (2001), *Bailey's Democracy* (2005) and *NY JS DB 62* (2007).

Website: www.david-bailey.co.uk

JONAS BENDIKSEN (b.1977)

Born in Norway, Bendiksen worked as an intern at the Magnum agency in London before traveling to the former Soviet Union, where he spent seven years on his Satellites project. From 2005 to 2007, he documented life in the densely populated slums of Nairobi, Mumbai, Jakarta and Caracas, focusing on the people who live in these cities and the problems they face. He has won several awards, including a World Press Photo award and a National Magazine Award in 2007. His work has appeared in *National Geographic*, *GEO*, *Newsweek*, and numerous other publications. He is based in New York.

Books: *Satellites: Photographs from the Fringes of the Former Soviet Union* (2006) and *The Places We Live* (2008).

Website: www.jonasbendiksen.com

HARRY BENSON (b.1929)

Harry Benson's first job was on the *Hamilton Advertiser* before he progressed to national newspapers with the *Daily Express*. He went to the USA to cover Beatlemania in 1964 and stayed on as the paper's New York correspondent, covering the political upheavals of the period. After refusing his paper's request to return to London, Benson carved out a career as a freelance photographer on *Life* magazine. He is now working under contract to *Vanity Fair* and *Architectural Digest*. He has published 12 books and had over 40 one-man exhibitions of his work. Benson was awarded a CBE in 2009. He lives in New York.

Books: Benson's books include *Harry Benson: 50 Years in Pictures* (2001), *Once There Was a Way: Photographs of the Beatles* (2004), *Harry Benson's America* (2005), *RFK: A Photographer's Journal* (2008) and *Harry Benson's Glasgow* (2007).

Website: www.harrybenson.com

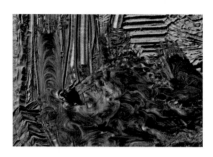 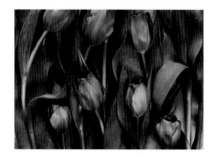 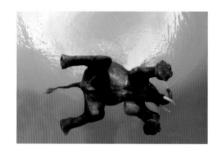

YANN-ARTHUS BERTRAND (b.1946)

Born in Paris, Bertrand worked in the film industry before becoming the manager of a nature reserve in France in 1967. He settled in Kenya in 1979 and produced his first book, *Lions*, in 1981. While in Kenya, he also became a hot-air balloon pilot and began aerial photography. In 1991 he founded the aerial photo-agency, Altitude, and embarked on his 'Earth from the Air' project in 1995. In 2005 he created www.goodplanet.org, a non-profit environmental organization. In 2006 he was awarded the Légion d'honneur for his photographic achievements relating to the environment. In 2009, his movie *Home*, an aerial journey around the planet, was released.

Books: Bertrand has produced over 80 books, including *The Earth from the Air* (1999), *Horses* (2004), *Being a Photographer* (2004) and *Our Living Earth: A Next Generation Guide to People and Preservation* (2008).

Website: www.yannarthusbertrand.com

JOHN BLAKEMORE (b.1936)

Blakemore's interest in photography began during his National Service in Tripoli in 1955. He decided to become a photographer a year later, after seeing images from the landmark 'Family of Man' exhibition published in *Picture Post*. He first worked as a freelance news photographer then in a portrait studio, while pursuing his own projects. In the 1970s, he became one of the best-known British landscape photographers, but in the 1980s and 90s he concentrated his energies on still-life work. He has been a lecturer in Photography at the University of Derby since 1970 and continues to explore photography today. He is an Honorary Fellow of the Royal Photographic Society.

Books: Blakemore's books include *The Stilled Gaze* (1994) and *John Blakemore's Black & White Photography Workshop* (2005).

Website: Blakemore has no website, but his work can be found on www.tristansgallery.com and www.hoopersgallery.co.uk

STEVE BLOOM (b.1953)

Bloom was born in South Africa and began working as a documentary photographer in the 1970s. He moved to England in 1977 due to his opposition to Apartheid. He worked in the graphic arts industry for many years and didn't return to his homeland until Apartheid had been abolished. He began photographing wildlife during a trip to South Africa in the early 1990s. Shortly afterwards he became a full-time photographer specializing in wildlife, although his most recent book, *Living Africa*, primarily features people. His work has been published in books, magazines, calendars, posters and advertisements.

Books: Bloom's books include *In Praise of Primates* (1999), *Untamed* (2004), *Elephant!* (2006) and *Living Africa* (2008).

Website: www.stevebloom.com

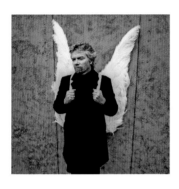

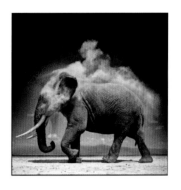

HARRY BORDEN (b.1965)

Borden grew up in the South West of England. He studied photography at Plymouth College of Art and Design, where he specialized in portraiture. He started shooting portraits for *The Observer* in 1994, and his work has since been seen in publications including *Harpers & Queen*, *Vogue* and *The New Yorker*. He has won two World Press Photo awards (in 1997 and 1999) and well over 100 of his portraits are in the National Portrait Gallery collection in London – more than any other photographer of his generation. In 2005 he held a solo exhibition at the National Portrait Gallery, titled 'On Business'.

Website: www.harryborden.com

POLLY BORLAND (b.1959)

Born in Melbourne, Australia, Borland has lived in Britain since 1989. She has an international reputation for portraiture and her subjects have included major politicians, performers and artists. She also shoots reportage projects on unusual or eccentric lifestyles and occasionally landscapes. Borland won the prestigious John Kobal Portrait Award in 1994. She has done extensive editorial work for publications including *The New Yorker*, *The New York Times* and *The Independent*. However, she now concentrates on exhibiting her photographs in galleries in London and Melbourne. Her work is in the permanent collection of the National Portrait Gallery in London and in its Australian counterpart in Canberra. She lives in Brighton.

Books: *Australians* (2000), *The Babies* (2001) and *Bunny* (2008).

Website: www.pollyborland.com

NICK BRANDT (b.1966)

Brandt studied Film and Painting at St Martin's School of Art in London. He began directing high-profile music videos and commercials in 1987, working with artists including Michael Jackson, and moved to the USA in 1993. He made his first serious photographic trip to East Africa, shooting with his Pentax 67 camera, in 2000. Since 2002, he has devoted himself to fine art photography on a full-time basis. He has published two books of his work and held numerous one-man exhibitions in galleries in London, Berlin, New York, Los Angeles and other major cities.

Books: *On This Earth* (2005) and *A Shadow Falls* (2009)

Website: www.nickbrandt.com

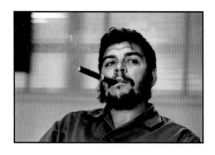

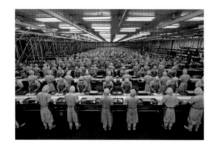

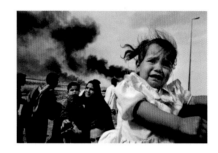

RENÉ BURRI (b.1933)

Burri was born in Switzerland and studied at the School of Arts and Crafts in Zurich (1949–53) where he specialized in photography. After military service in the Swiss Army, he published his first major story in *Life* magazine in 1955. He became an associate member of Magnum in 1956 and a full member in 1959. He began traveling widely on assignments for publications including *The New York Times*, *Stern* and *Life*, while also working on his own long-term projects. In 1998 he won the Dr Erich Salomon prize from the German Association of Photography for his outstanding work in photojournalism.

Books: Burri's many books include *Die Deutschen Photographien* (1962), *The Gaucho* (1968), *77 Strange Sensations* (1998) and his career retrospective, *René Burri Photographs* (2004).

Website: Burri has no website of his own, but a good selection of his work can be found on the Magnum site, www.magnumphotos.com

EDWARD BURTYNSKY (b.1955)

Burtynsky's family background is Ukrainian but he was born and raised in Canada. He studied Photographic Arts at Ryerson University, Toronto, graduating in 1982. In 1985 he began his career as a photographic artist, entrepreneur, author and educator, and founded Toronto Image Works. In the mid-1990s, his work became focused on environmental concerns and promoting ideas on sustainable thinking. It has been exhibited worldwide. In 2006, the award-winning documentary film *Manufactured Landscapes* recorded Burtynsky at work. His awards include the TED (Technology, Entertainment, Design) Prize in 2005 and three honorary doctorates. In 2007 he was awarded the title Officer of the Order of Canada.

Books: *Manufactured Landscapes* (2003), *China* (2005), *Quarries* (2007) and *Oil* (2009).

Website: www.edwardburtynsky.com

DAN CHUNG (b.1971)

Chung read Geography at Plymouth University then completed a NCTJ press photography course. This was followed by a traineeship with the *Derby Evening Telegraph* and a year at News Team Birmingham, before a six-year stint at the Reuters news agency. He began working as a staff photographer at The Guardian in 2003. He has traveled extensively in the course of his work and covered stories including the second Iraq War (2003), the Indonesian tsunami (2004) and the 2008 earthquake in China. His awards include the Nikon Press Photographer of the Year in 2002 and the Picture Editors' Guild Photographer of the Year in 2004.

Website: Dan Chung's blog and a selection of his images can be seen at http://commentisfree.guardian.co.uk/danchung

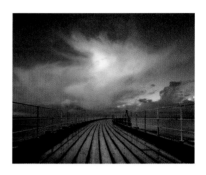
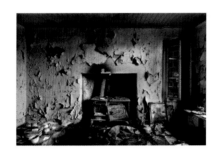
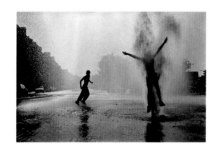

JOE CORNISH (b.1958)

Cornish studied art at Reading University and graduated in 1980. He began working as an assistant to different commercial photographers, but his passion lay in the natural world. He worked as a travel photographer from 1986–95, but a move to North Yorkshire in 1993 set off a new career direction as a landscape photographer. Cornish has worked with a 5x4in field camera since 1997. His work concentrates particularly on the remote and untamed regions of Scotland and the north of England. He was awarded an Honorary Fellowship of the Royal Photographic Society in 2008.

Books: *First Light: A Landscape Photographer's Art* (2002), *Scotland's Coast: A Photographer's Journey* (2005), *The Northumberland Coast* (2008) *and Scotland's Mountains: A Landscape Photographer's View* (2009).

Website: www.joecornish.com

DAVID CREEDON (b.1957)

Creedon was born in Cork, in the Republic of Ireland. He became fascinated by stage lighting as a teenager and started photographing local and touring bands in concert. Since then he has done both commercial photography and personal projects. He usually spends two or three years on each portfolio. They have included *Ghosts of the Faithful Departed*, *Variations on Pianoforte* and a series of atmospheric portraits of Irish musicians. He is an Associate of the Royal Photographic Society and a member of the British Institute of Professional Photographers.

Books: *Ghosts of the Faithful Departed* (2009).

Website: www.davidcreedon.com

NICK DANZIGER (b.1958)

Danziger has worked as an artist, author, documentary film-maker and photojournalist. He was born in London, but spent his schooldays in Switzerland and Monaco. He attended the Chelsea School of Art in London, afterwards working as an artist and visiting lecturer. In 1982 he was awarded a Winston Churchill Memorial Trust Fellowship and from his resulting experiences wrote the bestselling book *Danziger's Travels*. In 1991 he made the award-winning documentary video diary *War, Lives and Videotape*. He won first prize in the portrait category of the 2004 World Press Photo awards. Danziger was awarded an Honorary Fellowship by the Royal Photographic Society in 2007.

Books: Danziger has produced three books of travel writing illustrated with his photographs: *Danziger's Travels* (1987), *Danziger's Adventures* (1992) and *Danziger's Britain: A Journey to the Edge* (1996). His fourth book, *The British* (2001), is based on his photographic work in Britain from 1994 to 1999.

Website: www.nickdanziger.com

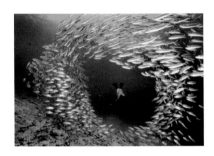
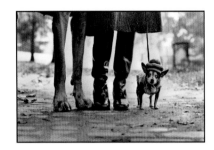
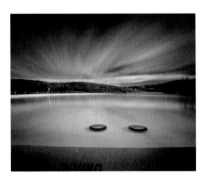

DAVID DOUBILET (b.1946)

Doubilet was born in New York and shot his first underwater images at the age of 12, improvising a housing for his Brownie Hawkeye with a rubber anesthesiologist's bag from his father's hospital. After graduating from Boston University in 1970, he worked as a diver and photographer in New Jersey. He photographed his first story for *National Geographic* in 1971 and has now produced over 60 stories for the magazine, for which he is currently a Contributing Photographer-in-Residence. He has received many awards, including the Lennart Nilsson Award in Photography (2001) and is a member of the International Diving Hall of Fame. He lives in Clayton, New York.

Books: Doubilet has produced seven books including *Water Light Time* (1999), *The Kingdom of Coral: Australia's Great Barrier Reef* (2002) and *Fish Face* (2003).

Website: www.daviddoubilet.com

ELLIOTT ERWITT (b.1928)

Erwitt was born in Paris to Russian parents and lived in Italy and France before emigrating to the US in 1939. He became interested in photography as a teenager and later studied the subject at Los Angeles City College. He began his professional career in 1949 and met Edward Steichen and Robert Capa, who both became important mentors. After doing military service, he joined the Magnum agency in 1953 and freelanced for *Life*, *Look* and *Holiday* magazines. He later turned to documentary film-making and comedy films. He now photographs for magazine, industrial and advertising clients and spends his spare time on books and gallery exhibitions of his personal work.

Books: Erwitt's numerous books include *Personal Exposures* (1988), *Dogdogs* (1998), *Personal Best* (2006) and *Elliott Erwitt's New York* (2008).

Website: www.elliotterwitt.com

CHIP FORELLI (b.1950)

After an early career as an architect and musician, Forelli turned to photography aged 27. He worked in a still-life studio for five years before becoming a freelance photographer and further developing his distinctive landscape photography style. In addition to teaching at the International Center of Photography in New York City and other institutions, he works as both a fine art and commercial photographer. Clients include BMW, Land Rover and Eastman Kodak. Forelli's work has been published in numerous magazines in the USA and Europe. He lives in the rural Delaware Valley in Pennsylvania.

Website: www.chipforelli.com

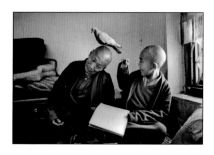

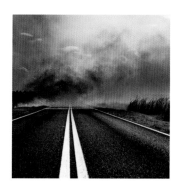

MARTINE FRANCK (b.1938)

Franck was born in Antwerp, Belgium and grew up in the UK and USA. She studied art history and began taking photographs at the age of 26. She initially worked at Time-Life in Paris, assisting photographers Eliot Elisofon and Gjon Mili, before working internationally as a freelance photographer. In 1970 she joined the Vu photo agency and married photojournalist Henri Cartier-Bresson a year later. She became a full member of Magnum in 1983. Her documentary projects have included the community on Tory Island and Buddhist monks in India and Nepal. In 2003 she opened the Henri Cartier-Bresson Foundation in Paris with her husband and daughter.

Books: Franck's books include *Tory Island Images* (1998), *One Day to the Next* (1999) and *Tibetan Tulkus: Images of Continuity* (2000).

Website: A wide selection of Franck's work can be found on the Magnum site, www.magnumphotos.com.

RALPH GIBSON (b.1939)

Gibson began his photographic career while serving in the US Navy. Afterwards, he studied photography at the San Francisco Art Institute. Early in his career, he was an assistant to two major figures in American photography, Dorothea Lange (1961–2) and Robert Frank (1967–8). He founded Lustrum Press in 1970, which has published books by other photographers including Mary Ellen Mark and Robert Frank, as well as Gibson's own work. He has been given many awards for his photography, including the Leica Medal of Excellence (1988), The Lucie Award (2007) and two honorary doctorates. He lives in New York.

Books: Gibson's many books include *The Somnambulist* (1970), *Days at Sea* (1975), *Deus Ex Machina* (1999), *Ex Libris* (2001) and *Light Strings* (2004).

Website: www.ralphgibson.com

JOSEF HOFLEHNER (b.1955)

Josef Hoflehner was born in Wels, Austria, when the country was still under allied occupation. After specializing in tourism at college, he began photography at the age of 20, while working in South Africa. He left his job to travel around the country and explore it photographically. Shortly afterwards he won a Nikon Award for one of his images and took up photography professionally. Hoflehner was presented with the Nature Photographer of the Year award in 2007 and was a Lucie Awards nominee in the same year. He exhibits regularly in New York City, Berlin, London and other major cities.

Books: Hoflehner's monographs include *Frozen History* (2003), *Unleashed* (2005), *Iceland* (2006) and *China* (2009).

Website: www.josefhoflehner.com

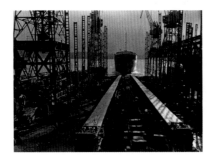

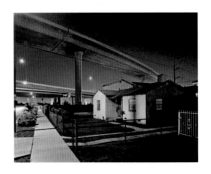

DAVID HURN (b.1934)

Hurn was born in England, though is from a Welsh background. He joined a photographic club while doing National Service and began his photographic career assisting at an agency in 1955. He covered the Hungarian revolution in 1956 but he soon abandoned current affairs work and chose to concentrate on personal projects. He joined Magnum as an associate member in 1965 and became a full member two years later. He set up the School of Documentary Photography in Newport, Wales, in 1973. His two most recent books have concentrated on Wales and its people. A new book of Welsh landscapes is due for publication in 2010.

Books: Hurn's books include *On Being a Photographer* (1997), *On Looking at Pictures* (2000), *Wales: Land of My Father* (2000) and *Living in Wales* (2003).

Website: A selection of Hurn's work, plus biographical information, can be found on the Magnum site, www.magnumphotos.com

COLIN JONES (b.1936)

Colin Jones was born into a working-class family in the East End of London. As a boy he discovered a love of ballet and, against the odds, became a dancer in the prestigious English Royal Ballet. He bought his first camera while on tour in Japan. After witnessing at first hand the aftermath of the Sharpeville Massacre in South Africa in 1960, he changed career and became a photographer. Since 1962 he has worked for major publications including *Life*, *National Geographic* and the *Observer*, photographing a range of documentary subjects including industrial workers and delinquent Afro-Caribbean young people in London.

Books: *Grafters* (2002), *The Black House* (2006).

Website: www.colinjonesphotography.co.uk

NADAV KANDER (b.1961)

Kander was born in Israel but grew up in Johannesburg. He began photographing at 13 and later, when drafted into the South African Air Force, worked in the darkroom printing aerial photographs. He moved to London in 1986. Since then he has become one of the most original and highly regarded advertising and fine art photographers working today. His work appears in publications including The *Sunday Times Magazine*, *Rolling Stone* and *Dazed & Confused*. In 2009, *The New York Times Magazine* devoted an entire issue to *Obama's People*, his 52 portraits of President Obama's inaugural administration. Kander has received numerous awards and his work is exhibited in museums and galleries internationally.

Books: *Beauty's Nothing* (2001), *Night* (2003).

Website: www.nadavkander.com

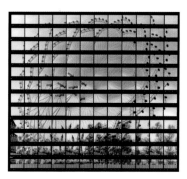

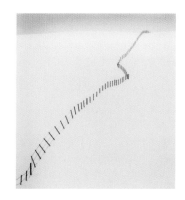

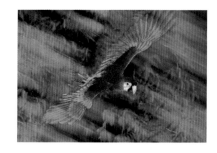

THOMAS KELLNER (b.1966)

Kellner was born in Bonn, Germany and studied art, sociology, politics and economics at the University of Siegen. In his art studies, his main interest was experimental and conceptual photography and he began to work using pinhole camera techniques, photograms and alternative printing processes. Since 1997 he has been creating his distinctive 'deconstructions' of exteriors and interiors of famous buildings worldwide. In 2003 and 2004, Kellner was a Visiting Professor of Fine Art Photography at the University of Giessen. His work has been exhibited in solo exhibitions in London, New York, Chicago and Boston.

Books: Kellner's books include *Ozymandias* (2004), *Dancing Walls*, 2003–2006 (2007) and *Thomas Kellner: All Shook Up* (2008)..

Website: www.tkellner.com

MICHAEL KENNA (b.1953)

Born in Lancashire, England, Kenna initially intended to become a Catholic priest before discovering a passion for the arts. He studied photography at Banbury School of Art and the London College of Printing and moved to San Francisco, USA, in 1977. He worked as a printer for the celebrated photographer Ruth Bernhard before becoming established as a fine art photographer in his own right. He has been devoted to landscape work for over 30 years. His awards include the Chevalier of the Order of Arts and Letters from the French Ministry of Culture (2000). He currently lives in Seattle, USA.

Books: Kenna's publications include *Michael Kenna Photographs* (1984), *Night Work* (2000), *Japan* (2003) and *Retrospective Two* (2004).

Website: www.michaelkenna.net

FRANS LANTING (b.1951)

Born in Rotterdam, Lanting completed a Master's Degree in Environmental Economics in 1977. The following year he emigrated to the USA to study at the University of California, but left to become a full-time nature photographer. Since then, he has photographed the natural world, specializing in wildlife. He began working for *National Geographic* in 1987 and is now a Photographer in Residence for the magazine. He won World Press Photo awards in 1988 and 1989 and was the BBC Wildlife Photographer of the Year in 1991. He became an Honorary Fellow of the Royal Photographic Society in 1999.

Books: Lanting has produced over a dozen books. His major publications include *Eye to Eye* (1997), *Penguin* (1999), *Living Planet* (1999), *Jungles* (2000) and *Life: A Journey Through Time* (2006).

Website: Lanting's main site is www.franslanting.com. There is also a separate website on his *Life* project, www.lifethroughtime.com

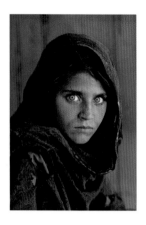

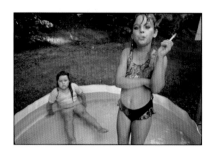

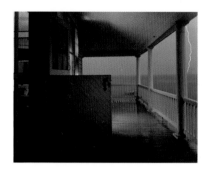

STEVE MCCURRY (b.1950)

McCurry studied film and cinematography at Pennsylvania State University before working as a newspaper photographer for two years. He then traveled and worked freelance. He photographed the conflict in Afghanistan after the Russian invasion in 1979 and his work received international recognition. Since then he has carried out assignments all around the world, primarily for *National Geographic* magazine. He has covered conflicts in the former Yugoslavia, Beirut, Cambodia, Iraq and Afghanistan. His numerous awards include an unprecedented four first prizes in the World Press Photo awards. He has been a full member of Magnum since 1986.

Books: McCurry has published many books, including *The Imperial Way* (1985), *Monsoon* (1988), *Portraits* (1999), *Sanctuary: The Temples of Angkor Wat* (2002), *In The Shadow of Mountains* (2007) and *The Unguarded Moment: Thirty Years of Photography* (2009).

Website: www.stevemccurry.com

MARY ELLEN MARK (b.1940)

Mark began photographing with a box brownie camera at the age of 9. She went on to study painting and art history at the University of Pennsylvania. She pursued a career as a freelance photographer from the early 1960s and became known for her photo-essays focusing on social issues. She joined the Magnum agency in 1977 but left five years later. She has published work in *Rolling Stone*, *Vanity Fair*, *Life* and the *New York Times* magazine. Her many awards include five honorary doctorates and three World Press Photo awards; one of them, in 1988, was for her outstanding body of work. She is currently a contributing photographer to *The New Yorker*.

Books: Mark has published sixteen books to date, including *Passport* (1974), *Ward 81* (1979), *Falkland Road: Prostitutes of Bombay* (1981), *American Odyssey* (1999) and her career retrospective *Exposure* (2006).

Website: www.maryellenmark.com

JOEL MEYEROWITZ (b.1938)

Meyerowitz began photographing in 1962. He initially shot street pictures in black and white, but by the mid 1960s had become an influential advocate of color photography. His first book, *Cape Light*, has now sold over 130,000 copies. More recently, he comprehensively photographed the aftermath of the 9/11 attacks on the World Trade Center in New York and the resulting exhibition, *Aftermath*, was seen by over 4 million people around the world. A book looking back at his career will be published in 2010. He has twice been a Guggenheim fellow and his other awards include an Honorary Fellowship of the Royal Photographic Society (2002). He lives in New York.

Books: *Cape Light* (1978), *St. Louis and The Arch* (1981), *Bystander: A History of Street Photography* (1994), *Tuscany: Inside the Light* (2003) and *Aftermath: The World Trade Center Archive* (2006).

Website: www.joelmeyerowitz.com

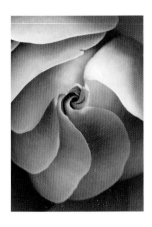

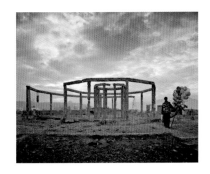

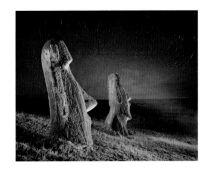

CLIVE NICHOLS (b.1962)

Nichols studied Human Geography at Reading University in the early 1980s before taking up a career as a chef. Finding that he had a greater interest in photography, he began working as a travel photographer before discovering his métier in plant and garden photography. His work has appeared in numerous magazines, books and calendars around the world and he was voted Garden Photographer of the Year in 2005 by the Garden Writers' Guild (now the Garden Media Guild). He sits on the Royal Horticultural Society Photographic Committee and is a judge for the Garden Photographer of the Year competition. He lives in Oxfordshire.

Books: *New Shoots* (2000) and *The Art of Flower & Garden Photography* (2007).

Website: www.clivenichols.com

SIMON NORFOLK (b.1963)

Norfolk was born in Lagos, Nigeria, and educated in England, finishing at Oxford and Bristol Universities. He attended a Documentary Photography course at Newport, South Wales, then worked for far-left publications specializing in work on anti-racist activities and fascist groups in Britain. His photography has focused on the aftermath of major international conflicts in Afghanistan and Bosnia, and genocide in many countries around the world. His awards include a World Press Photo award (2001) and the Infinity Award from the International Center for Photography in New York (2004). Norfolk's work regularly appears in *The New York Times* and *Guardian Weekend* magazines.

Books: *For Most Of It I Have No Words: Genocide, Landscape, Memory* (1998), *Afghanistan: Chronotopia* (2002) and *Bleed* (2005).

Website: www.simonnorfolk.com

SIMON PARK (b.1965)

Park was born in Blackburn, England, and educated at Stonyhurst College in Lancashire. He studied Art & Design at the Isle of Man College and undertook a degree in Scientific and Technical Graphics at Falmouth College of Art & Design from 1984 to1988. He later settled on the Isle of Man and now works as a professional photographer specializing in fine art and commercial work. His work is influenced by a diverse range of photographers from Ansel Adams to Robert Mapplethorpe. Park's work includes landscapes (particularly at sites of ancient historical interest), street photography and still-life floral studies.

Books: Park has shot all the images for *Three Legs in the Irish Sea* (2008), a book about the Isle of Man.

Website: www.simonparkphotography.co.uk

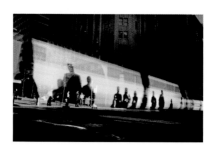

TRENT PARKE (b.1971)

Parke was brought up in New South Wales, Australia. He began photographing at the age of 12, using his mother's Pentax Spotmatic camera. In 2003 he traveled 56,000 miles around Australia with his wife and fellow photographer Narelle Autio. His portfolio of work from this trip was published as *Minutes to Midnight* and won Parke the W. Eugene Smith Grant in Humanistic Photography in 2003. He has also won four World Press Photo awards. He became a full member of Magnum in 2007 and is the only Australian photographer to be represented by the agency. He lives in Adelaide.

Books: *Dream/Life* (1999), *The Seventh Wave* (2000), *Minutes to Midnight* (2005).

Website: A selection of Parke's work can be seen on the Magnum website, www. magnumphotos.com, and the street photography website, www.in-public.com

MARTIN PARR (b.1952)

Parr's initial interest in photography was encouraged by his grandfather, George Parr. After studying photography at Manchester Polytechnic in the early 1970s, Parr became a freelance photographer. He initially worked in black and white, but started using high-saturation colour film and ring flash in the mid 1980s. This combination gave rise to his signature style. His photographic output has been prolific and his distinctive documentary work has an international reputation. He became a member of Magnum in 1994 and Professor of Photography at the University of Wales in 2004. In 2006 he was awarded the Dr. Erich Salomon Prize for Photojournalism.

Books: Parr has produced more than 50 books, including *The Last Resort* (1986), *Bored Couples* (1992), *Small World* (1995), *Common Sense* (1999) and *Think of England* (2000).

Website: www.martinparr.com

PAOLO PELLEGRIN (b.1964)

Pellegrin was born in Rome and initially studied architecture before taking up photography. He became a full member of the Magnum agency in 2005 and currently works as a photojournalist for *Newsweek* magazine. He has won numerous awards, including eight World Press Photo awards (between 1995 and 2007), a Leica Medal of Excellence (2001) and a Robert Capa Gold Medal Award (2007). His assignments have included documenting conflicts in Lebanon and Kosovo, refugees in Darfur and people living in the slums of Mumbai. He travels on assignment for around 300 days per year and divides the remaining time between Rome and New York.

Books: Pellegrin's books include *Cambodia* (1998), *Kosovo 1999–2000: The Flight of Reason* (2002), *Double Blind: Lebanon Conflict 2006* (2007) and *As I was Dying* (2007).

Website: A selection of Pellegrin's work can be found on the Magnum website, www.magnumphotos.com

MARK POWER (b.1959)

Power began his artistic life in drawing and painting, but, inspired by an exhibition of Don McCullin's work, he turned to photography in 1983. He carried out editorial and charity projects until he began teaching in 1992. At the same time, he started working on his own long-term projects and large scale industrial sector commissions. His recent projects have included *A-380*, a book about the development of the world's largest passenger airplane. Power joined Magnum Photos as a Nominee in 2002 and became a full member in 2005. He is the Professor of Photography at the University of Brighton.

Books: *The Shipping Forecast* (1996), *Superstructure* (2000), *The Treasury Project* (2002) and *26 Different Endings* (2007).

Website: www.markpower.co.uk

STEVE PYKE (b.1957)

Pyke was born in Leicester, England, and left school at the age of 16 to work as a factory mechanic. He later became involved in the music industry and was the singer in a band. However, he quit the music scene in 1980, initially working as a photographer on style magazine *The Face*. Aside from his professional work, he has carried out a number of self-funded projects, including portraits of astronauts, philosophers and Holocaust survivors. He has worked for a number of leading magazines and in 2004 became a staff photographer on *The New Yorker*. He was awarded an MBE for his work in the same year.

Books: Pyke's books include *Philosophers* (1993), *Post Mortem* (2005), *Post Partum* (2005) *and Earthward* (2009).

Website: www.pyke-eye.com

HUMPHREY SPENDER (1910-2005)

Spender was born into a liberal upper middle-class family. Although trained as an architect, he didn't follow the profession. He began shooting documentary pictures, first in the slums of Stepney, East London (1934) and later in Bolton, Lancashire (1937). He joined *Picture Post* in 1938 and was conscripted into the British Army in 1941. By the end of the war his interest in photography was waning and he carried out his last assignment in 1953. He then taught in the textile school of the Royal College of Art until his retirement in 1975. He was awarded an Honorary Fellowship of the Royal Photographic Society in 2005.

Books: *Worktown People: Photographs from Northern England, 1937–38* (1982), *'Lensman' Photographs 1932–52* (1987) and *Humphrey Spender's Humanist Landscapes: Photo-documents 1932–1942* (1997).

Website: Over 200 of Spender's images are on the Getty Images website (www.gettyimages.com). A selection of his 'Worktown' photographs for the Mass-Observation project is online at www.boltonmuseums.org.uk

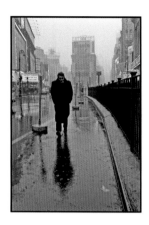

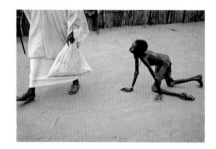

DENNIS STOCK (b.1928)

Born in New York, Stock was apprenticed to the US Navy at the age of 17. He showed great promise as a photographer from a young age, and became the assistant to legendary *Life* photographer Gjon Mili in 1947. He joined the Magnum agency in 1951. Stock has always been more of a photographic essayist, shooting a series of images on a subject, than a photojournalist covering one-off events. His most famous images come from long-term projects on Hollywood stars, jazz musicians, Hell's Angels and communal living. He has also worked as a writer, director and producer for television and film. He lives in New York.

Books: Stock's numerous books include *Jazz Street* (1960), *California Trip* (1970), *Brother Sun* (1974), *Made in USA* (1995) and *James Dean: Fifty Years Ago* (2005).

Website: A selection of Stock's work can be seen on the Magnum website, www.magnumphotos.com

TOM STODDART (b.1953)

Stoddart first worked as a photographer on provincial newspapers in the north of England. He moved to London in 1978 and began freelancing for national newspapers and magazines. Since then he has covered major international news events including the siege of Sarajevo, floods in Mississippi, genocide in Rwanda, the fall of the Berlin Wall and the Romanian Revolution. His many accolades include prizes in the World Press Photo awards (1995 and 2001) and the Nikon Photographer of the Year Award (1991 and 1992). He continues to work on campaigning photographic projects examining contemporary issues.

Books: Stoddart's books include *Edge of Madness: Sarajevo, A City and its People Under Siege* (1997) and his career retrospective, *iWitness* (2004).

Website: www.tomstoddart.com

MATT STUART (b.1974)

Born in north-west London, Stuart initially worked as a photographer's assistant for three years. He began his career as a freelancer in 2000. His interest in street photography grew out of a teenage passion for skateboarding. Influenced by Garry Winogrand, Joel Meyerowitz and Tony Ray-Jones, he began photographing in London's streets in 1998. He now combines his personal work with commercial work for clients including Sony, Fuji, Tate Modern and Sainsbury's. Stuart is working on a book of his street pictures. He lives in London.

Website: Stuart's website is www.mattstuart. com. A selection of his work can also be seen on the street photography website www.in-public.com

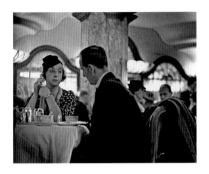

WOLF SUSCHITZKY (b.1912)

Wolf Suschitzky was born in Austria and studied photography in Vienna. He left his homeland to live in London in 1935. He began by working for *Illustrated* magazine and later its rival, *Picture Post*. This work included documentary photographs of street life and manual workers, as well as portraits of famous people including HG Wells and Alexander Fleming. He also carried out his own personal projects, such as his *Charing Cross Road* portfolio. From the 1940s onwards he began working in the film industry and went on to be the cinematographer on around 200 films, including *Ulysses* (1967) and *Get Carter* (1971). He lives in London.

Books: *Charing Cross Road in the Thirties* (1989) and *Wolf Suschitzky: Photos* (2006).

Website: A small selection of Suschitzky's work can be seen on the Photographer's Gallery website, www.photonet.org.uk

JOHN SWANNELL (b.1946)

Swannell left school at 16 and assisted at Vogue Studios before working as David Bailey's assistant for four years. He then set up his own studio. During the next decade he traveled and had work published in major international magazines such as *Vogue*, *Harpers & Queen* and *Tatler*. He has photographed many famous public figures, including most of the Royal Family, as well as numerous celebrities. His images are held in the collections of the National Portrait Gallery in London and the Museum of Modern Art in New York. He was awarded a Fellowship of the Royal Photographic Society in 1993. Swannell divides his time between portraits, fashion, nudes and landscapes.

Books: Swannell's books include *Fine Lines* (1982), *Naked Landscape* (1986), *Twenty Years On* (1996), *I'm Still Standing* (2002) and *John Swannell Nudes, 1978–2006* (2007).

Website: www.johnswannell.com

DENIS THORPE (b.1932)

Born in Nottinghamshire, England, Thorpe's first job was on the *Mansfield Reporter* (1948–50). After National Service he worked for other regional newspapers before joining the *Daily Mail* in 1957. In 1974, he joined *The Guardian* as a staff photographer based in Manchester. He remained with the newspaper until his retirement in 1996. His awards include The British Press Awards Regional Photographer of the Year (1971), a World Press Photo award (1979) and The Ilford Photographer of the Year (1988). He became a Fellow of the Royal Photographic Society in 1990.

Books: Thorpe's books include *Shepherd's Year (1979)*, *Denis Thorpe: 50 Years, 1950–2000* (2000) and *A Long Exposure: Pictures from 100 Years of Guardian Photography in Manchester 1908–2008* (2008).

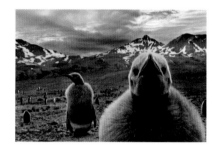

CHARLIE WAITE (b.1949)

After leaving school, Charlie Waite worked in theater and television for ten years before becoming a professional photographer. He initially shot portraits but began specializing in landscape photography in 1980. He produced the images for his first book, the *National Trust Book of Long Walks*, the same year. He has now produced almost 30 books and is undoubtedly one of Britain's most popular landscape photographers. He has held solo exhibitions in Europe, the USA, Japan and Australia. Waite founded 'Light & Land', the leading photographic tour company, in 1994. In 2006 he launched the 'Take a View' Landscape Photographer of the Year competition.

Books: Waite's books include *The Making of Landscape Photographs* (1992), *In My Mind's Eye* (2004) and *Landscape: The Story of Fifty Favourite Photographs* (2005).

Website: www.charliewaite.com

ALBERT WATSON (b.1942)

Although blind in one eye since birth, Watson studied graphic design at art college in Dundee, then film and television at the Royal College of Art. He moved to the USA in 1970. He has shot more than 250 covers for *Vogue* and his images have featured in major publications worldwide. In addition, he has photographed hundreds of high-profile advertising campaigns. Watson has also created an extensive body of fine art work that is exhibited in museum and gallery shows worldwide along with many of his well-known photographs. He has been named as one of the 20 most influential photographers of all time by the *Photo District News*.

Books: *Cyclops* (1994), *Maroc* (1998) and the career retrospective *Albert Watson* (2007). His book *Shot in Vegas* will be published in 2010.

Website: www.albertwatson.net

ART WOLFE (b.1951)

Wolfe was born in Seattle and graduated from the University of Washington with degrees in fine arts and art education. Within four years he had completed assignments for *National Geographic* magazine and produced his first photography book. During the course of his 30-year career Wolfe has worked in hundreds of locations around the world; he estimates that he has shot around one million images. He is an Honorary Fellow of the Royal photographic Society and a Fellow of the International League of Conservation Photographers. He spends around nine months of each year travelling and also lectures widely. He presents the TV documentary series *Art Wolfe's Travels to the Edge*.

Books: Wolfe has produced over 60 books, including *Light on the Land* (1991), *Migrations* (1994), *Edge of the Earth, Corner of the Sky* (2003), *Vanishing Act* (2005) and *On Puget Sound* (2007).

Website: www.artwolfe.com

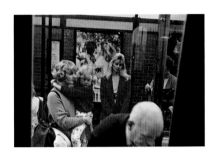

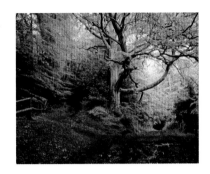

TOM WOOD (b.1951)

Tom Wood grew up in Cowley, Oxford and studied Fine Art at Leicester Polytechnic (1973–76). He taught photography in Merseyside part-time from 1978 to 1997 and photographed the social landscape around Liverpool during the rest of the week. He has published several books of his individual brand of documentary photography and his work was included in the book *Bystander: The History of Street Photography*. He was given the Royal Photographic Society's Terence Donovan Award in 1998 and the Prix Dialogue de l'Humanité at Recontres d'Arles, France, 2002. Wood is currently working on a number of long-term photographic projects. He lives in North Wales.

Books: Wood's books include *All Zones Off Peak (1998), Bus Odyssey* (2001) and *Photie Man* (2005).

Website: Wood currently does not have a website, but information and useful links can be found on www.wikipedia.org

HARRY CORY WRIGHT (b.1963)

Wright became interested in photography in his early teens and began his professional career with private commissions for magazines including *Country Living and Homes & Gardens*. He later specialized in landscape work. Since 1995, his camera of choice has been a 10x8 inch, wood and brass Gandolfi camera. He carries out advertising work for clients including Conran and Dulux plus editorial assignments for publications including the *Telegraph, Independent* and *Times* magazines. He also does public and private commissions. He established the Saltwater Gallery in Norfolk in 2000 (www.saltwater.co.uk), which sells his limited edition photographs.

Books: *Journey Through the British Isles* (2007).

Website: www.harrycorywright.com

ACKNOWLEDGEMENTS

Firstly, my thanks go to all 50 photographers whose work appears in this book. They have generously given their time and offered invaluable insights into their work and photography in general. Interviewing them and selecting their work has been a fascinating journey in itself.

My contact with many of these photographers goes back to the nine years I spent as a journalist at *Amateur Photographer* magazine. In some cases I have reproduced quotes given to me during interviews I carried out while working for *AP*. My thanks go to IPC Media and the magazine's Editor, Damien Demolder, for permission to use that material in this book.

This book would not have existed without the encouragement of Argentum's commissioning editor, Eddie Ephraums. He originally suggested the idea of encapsulating photography in 100 words and his sound advice and design expertise has shaped the book through its many stages. Eddie, thank you. I'd also like to thank two of his colleagues: Piers Burnett, for having faith in the idea, and Stuart Cooper for his commitment to producing a coherent, high-quality book.

On a personal note, I would also like to thank my elder brother John, who generously bought me my first SLR camera when I was 15 years old and first encouraged what has become a lifelong interest in photography.

Finally, special thanks go to my wife Antonia and my children Alastair and Jonathan, for supporting me and being patient during the months it took to research and write this book.

PICTURE CREDITS

Copyright for the images in the book is owned by the following individuals or organisations:

Page 9: David Bailey; page 11: Jonas Bendiksen/Magnum Photos; page 13: Harry Benson; page 15: Yann Arthus-Bertrand/Altitude; page 17: John Blakemore; page 19: Steve Bloom/stevebloom.com; page 21: Harry Borden; page 23: Polly Borland; page 25: Nick Brandt; page 27: René Burri/Magnum Photos; page 29: Edward Burtynsky, courtesy Flowers East Gallery, London; page 31: Dan Chung/Guardian News & Media Ltd 2004; page 33: Joe Cornish; page 35: David Creedon; page 37: Nick Danziger/NB Pictures 2001; page 39: David Doubilet/Undersea Images Inc; page 41: Elliott Erwitt/Magnum Photos; page 43: Chip Forelli; page 45: Martine Franck/Magnum Photos; page 47: Ralph Gibson; page 49: Josef Hoflehner; page 51: David Hurn/Magnum Photos; page 53: Colin Jones; page 55: Photography by Nadav Kander; page 57: Thomas Kellner; page 59: Michael Kenna; page 61: Frans Lanting Photography; page 63: Steve McCurry; page 65: Mary Ellen Mark; page 67: Joel Meyerowitz; page 69: Clive Nichols; page 71: Simon Norfolk; page 73: Simon Park; page 75: Trent Parke/Magnum Photos; page 77: Martin Parr/Magnum Photos; page 79: Paolo Pellegrin/Magnum Photos; page 81: Mark Power/Magnum Photos; page 83: Steve Pyke; page 85: The Humphrey Spender Archive; page 87: Dennis Stock/Magnum Photos; page 89: Tom Stoddart/Getty Images; page 91: Matt Stuart; page 93: Wolf Suschitzky; page 95: John Swannell; page 97: Denis Thorpe/The Guardian; page 99: Charlie Waite; page 101: Albert Watson; page 103: Art Wolfe/www.artwolfe.com; page 105: Tom Wood; page 107: Harry Cory Wright

Focal Press is an imprint of Elsevier
30 Corporate Drive, Suite 400, Burlington, MA 01803, USA

This book has been produced by Aurum Press Limited, 7 Greenland Street, London NW1 0ND

Library of Congress Control Number: A catalog record for this book is available from the Library of
Congress

ISBN: 978-0-240-81300-4

For information on all Focal Press publications visit our website at: www.focalpress.com

Printed and bound in Singapore

09 10 11 12 12 11 10 9 8 7 6 5 4 3 2 1